★
ICONS

SURFING

VINTAGE SURFING GRAPHICS

Jim Heimann

TASCHEN

KÖLN LONDON LOS ANGELES MADRID PARIS TOKYO

Cover: San Onofre, California,
photograph, LeRoy Grannis, 1963
Endpaper: Fabric pattern, ca. 1942
Inside back endpaper: Poster, 1963

Acknowledgments

Mahalo to all who contributed to the gathering of the surfing images and information found herein. Among them
are Tommy Steele, Buck Labadie, LeRoy Grannis, Ralph Bowman, Michael Doret, Patrick Jenkins, Dan De Palma,
Jean and Bill Gold, Jeff and Patty Carr, Gary Fredericks, Jim Salvati, Robert Williams, Steve Pezman and the
countless other vendors at flea markets and paper shows on the mainland and Hawaii.

Cowabunga to Cindy Vance for continuing to patiently and methodically produce the all the additional digital
materials for this and other books. Hang Ten to Nina Wiener for her indefatigable editing of text and monitoring
every aspect of this project. And to the Artworks crew, a big lei for continuing to provide on-the-spot digital and
photographic service.

Special thanks go out to Paul Mussa for keeping things simple; Thomas Grell, our Cologne-L. A. production
connection; Ethel Seno, Drew Tewskbury, Danielle Hylton, and Kate Soto for their undivided assistance.

All images are from the Jim Heimann collection unless otherwise noted. Any omissions for copy or credit
are unintentional and appropriate credit will be given in future editions if such copyright holders contact the
publisher.

To stay informed about upcoming TASCHEN titles, please request our magazine at www.taschen.com or write to
TASCHEN, Hohenzollernring 53, D–50672 Cologne, Germany, Fax: +49-221-254919. We will be happy to send you
a free copy of our magazine which is filled with information about all of our books.

Editor: Jim Heimann, Los Angeles
Design: Paul Mussa, San Francisco
Production: Tina Ciborowius, Cologne
Project management: Sonja Altmeppen, Cologne
English-language editor: Nina Wiener, Los Angeles
German translation: Anke Caroline Burger, Berlin
French translation: mot.tiff, Paris

Printed in Italy
ISBN 3–8228–3007–0

Goin' with the Flow

Although no written account of the first human attempt to ride the waves exists, it is generally acknowledged that the sport of surfing was spawned in the South Pacific more than four thousand years ago. A casual pastime, ancient surfing was accomplished – prone or on one's knees – on any available floating device, from a single log to a bundle of reeds. It was not until around 1000 ad that surfers in the Polynesian archipelago of Hawai'i perfected the art of standing while riding waves. A highly developed sport of both commoners and kings, Hawaiian royalty, such as King Kamehameha I, utilized his athletic prowess on the surfboard as a means to confirm his status and social standing, a common practice throughout the island communities.

The sport of surfing was introduced to the West in 1779 by the writings of Lieutenant James King, a member of the British expedition led by Captain James Cook that landed on the islands in the previous year. His account, the first known mention of surfing in writing, painted a picture of an exotic and curious diversion greatly enjoyed by the locals.

The arrival of Europeans exposed Hawai'i as an excellent trading crossroads and soon whalers, merchants and vagabonds discovered this mid-Pacific paradise. The arrival of missionaries, however, proved to be the most devastating blow to the ancient sport of surfing. Calvinist Christians who arrived from England in 1821 frowned on many of the native traditions, especially those that displayed naked flesh or were considered frivolous. As a result, the sport and most remnants of Hawaiian cultural tradition all but disappeared for the remainder of the nineteenth century. Within years, only a few native practitioners – as well as interest from tourists such as American author Mark Twain, who wrote of his attempts at "surf-bathing" in his book, *Roughing It* (1872) – were keeping the sport from extinction.

By the turn of the twentieth century, the United States had annexed the Hawaiian Islands. Transportation from the mainland to the islands improved and promotional magazines such as the long-running *Paradise of the Pacific* were launched. Depictions of island life, including images of surfing, were instrumental in luring tourists by ocean liner.

The resurrection of surfing culture did not occur, however, until two major figures emerged on the scene: George Freeth, who introduced surfing to the mainland, and Duke Kahanamoku, widely considered to be the father of modern-day surfing. Half-Irish, half-Hawaiian, Freeth was a member of a loose-knit group of "beach boys" who practiced the

Magazine cover, 1936

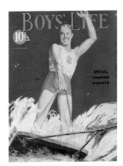

now-rare sport at Waikiki Beach. In 1907 he was introduced to the renowned American writer, Jack London, vacationing with his wife in Honolulu. Impressed by Freeth's athletic prowess on the waves, London wrote a magazine article published in the widely read magazine *Woman's Home Companion*. A minor celebrity as a result, Freeth made his way to Southern California. He demonstrated his wave riding for crowds at Venice Beach, where he lived and established himself as a top lifeguard. Soon Freeth was on the payroll at railroad magnate and real estate developer Henry Huntington's beachside development in nearby Redondo Beach, where he promoted Freeth as "the man who could walk on water."

If Freeth brought surfing to the mainland, Duke Kahanamoku brought it to the world. A native Hawaiian and gifted aquatic athlete, Kahanamoku was also a Waikiki beach boy and helped found the surfing club *Hui Nalu* (Club of the Waves) in 1905. As a young man, he was breaking world-swimming records, and in 1912 he traveled to the Olympics in Stockholm, Sweden as a member of the American swimming team. On the way, he created a sensation with his surfing demonstrations in Santa Monica and Corona del Mar, California. His multiple gold medals at the Olympics formalized his position as the unofficial ambassador of Hawai'i, and the international exposure sparked a lifetime of traveling the world proselytizing the sport of surfing.

The new century in full swing, the visuals associated with surfing expanded beyond their use simply in promotional material for the islands. Celebrities posed for photographers at Waikiki Beach, on or next to surfboards. American magazine publishers featured surfers (or models posed as surfers) on their covers, while Hawaiian souvenirs liberally featured wave riders.

As a general awareness of surfing spread, California became the next big spot for the sport to flourish. In 1928, Wisconsin-born surfer Tom Blake helped organize the first Pacific Coast Surfriding Championships at Corona del Mar, which he won on a hollow surfboard he had built himself. Groups of young athletes along the coast were developing a casual surfing lifestyle, designing their own boards and adopting the easygoing Hawaiian attitude. Though surfers in the thirties and forties maintained a low profile, they were often portrayed in the press as athletic nonconformists. Surf photographers, such as John "Doc" Ball, captured these early and innocent years of the sport in California, both revealing and confirming a way of life that was to be envied and copied in years to come.

Movie handbill, 1967

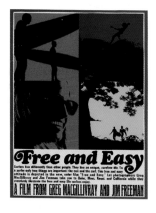

Movie poster, 1962

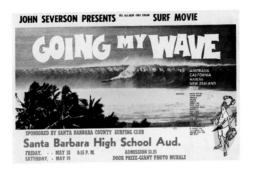

Technological innovations after World War II transformed the surfboard from an unwieldy slab of redwood to a sleek platform for traversing the waves, while surfers were constantly changing the surfboard's shape, weight and maneuverability. Board design accelerated with the introduction of lightweight balsa wood, resin and fiberglass, while the sport itself became increasingly accessible and popular. For the most part, surfers were considered to be unconventional free spirits, with the media images generated after the War setting the stage to transform surfing from a sport into a lifestyle.

Jet travel to Hawai'i in the late fifties opened up the floodgates of tourism, ending the islands' relative isolation and exposing surfing to thousands of visitors. Across the Pacific, Australia began to establish itself as a third surfing center, when lightweight balsa boards were introduced in 1956. The release three years later of the film *Gidget*, a Hollywood version of real-life sixteen-year-old Kathy Kohner's innocent surfing exploits at Malibu Beach, made waves at the box office, altering the sport's image forever. As California emerged as a fountainhead of youth culture in the late fifties, surfing saturated the entertainment media – from the mega-hits of the Beach Boys to the sanitized beach movies featuring Annette Funicello and Frankie Avalon.

Images of surfers and surfing appeared in advertisements and album packaging (selling anything and everything except the actual activity of surfing) and surfboards and board shorts began to be manufactured for the mass market. Both the profits and the crowded beaches resulting from surfing's new-found popularity greatly dismayed many hardcore surfers. By the late sixties, corporate-sponsored contests and drugs further tainted a sport that had lost its innocence. Spin-off sports such as windsurfing, skateboarding and snowboarding developed their own tangential subcultures, each with its own trends, slang and graphics. By the eighties, major endorsement deals offered to the athletes and a burgeoning casual clothing market, soon dominated by surf wear, further commercialized the sport.

Despite the conflict of commercialization versus the personal pursuit of the wave, surfing continues to inspire a global following of participants and admirers. Drawn to the mystique of an alternative lifestyle and an endless summer, the lure of the wave and the images it inspires, the surfer endures as one of the most universally recognized symbols of personal freedom.

Die Jagd nach der perfekten Welle

Es gibt zwar keine schriftlichen Belege für die ersten Versuche des Menschen, auf den Wellen zu reiten, man nimmt jedoch an, dass der Surfsport vor über viertausend Jahren im Südpazifik seine Geburtsstunde erlebte. Anfangs wurde das Wellenreiten zum Zeitvertreib auf jeder Art von Schwimmkörper betrieben, vom einzelnen Baumstamm bis hin zum Schilfbündel – in Bauchlage oder auf den Knien. Erst um 1000 n. Chr. perfektionierten Surfer auf der polynesischen Inselgruppe Hawaii die Kunst, im Stehen auf den Wellen zu reiten. Hier wurde Surfen bei Bürgerlichen und Adligen zum hoch entwickelten Sport, und Herrscher wie König Kamehameha I. verschafften sich durch ihr athletisches Können auf dem Surfboard Rang und Ansehen.

Wellenreiten als Sport wurde im Westen 1779 durch Leutnant James King bekannt, der an der britischen Entdeckungsreise unter Captain James Cook teilgenommen hatte. Kings Reisebericht, die erste schriftliche Erwähnung des Surfens, zeichnete das Bild eines exotischen und äußerst merkwürdigen Zeitvertreibs, der bei den Südseeinsulanern sehr beliebt war.

Mit der Ankunft der Europäer wurde Hawaii ein wichtiger Knotenpunkt für den Seehandel, und sehr bald entdeckten Walfänger, Handelsleute und Vagabunden das Paradies mitten im Pazifischen Ozean für sich. Die Ankunft der Missionare sollte sich jedoch als schwerer Rückschlag für den uralten Surfsport erweisen. Den Calvinisten, die 1821 aus England eintrafen, waren viele der einheimischen Traditionen ein Dorn im Auge, besonders solche, die viel nackte Haut zur Schau stellten. Das Ergebnis war, dass der Surfsport zusammen mit dem Großteil der hawaiianischen Kultur für den Rest des 19. Jahrhunderts praktisch von der Bildfläche verschwand. Innerhalb weniger Jahre gab es nur noch eine Hand voll Einheimischer sowie einige Touristen, die diesen Sport vor dem Aussterben bewahrten. Zu ihnen zählte zum Beispiel Mark Twain, der in seinem Buch *Durch Dick und Dünn* (1872) von seinen Versuchen beim „Brandungsbaden" berichtete.

Um die Jahrhundertwende wurden die Hawaii-Inseln von den Amerikanern annektiert. Es gab regelmäßigen Schiffsverkehr zwischen Festland und Inseln und Werbemagazine wie das *Paradise of the Pacific* erschienen. Herrliche Bilder des Südseelebens, zu denen auch Darstellungen vom Surfen gehörten, sollten Touristen zur Anreise mit dem Ozeandampfer verleiten.

Zur Wiederauferstehung der Surfkultur kam es jedoch erst, als zwei wichtige Figuren auftauchten: George Freeth, der das Wellenreiten aufs amerikanische Festland brachte, und

Decal, ca. 1963

Duke Kahanamoku, der allgemein als Vater des modernen Surfsports gilt. Der halb irische, halb hawaiianische Freeth gehörte einer losen Gruppe von „Beach Boys" an, die den ungewöhnlichen Sport am Waikiki Beach ausübten. 1907 lernte Freeth den bekannten amerikanischen Schriftsteller Jack London kennen, der mit seiner Frau Urlaub in Honolulu machte. London war beeindruckt von Freeths athletischen Fähigkeiten und schrieb einen Artikel über ihn, der in der viel gelesenen Zeitschrift *Woman's Home Companion* veröffentlicht wurde. Dadurch erlangte Freeth einen gewissen Bekanntheitsgrad und zog nach Südkalifornien, ließ sich in Venice Beach nieder und wurde als Rettungsschwimmer und Wellenreiter gefeiert. Schon bald wurde er von dem Großindustriellen und Immobilienhändler Henry Huntington für dessen Strandsiedlung im nahe gelegenen Redondo Beach engagiert, wo man ihn als „Mann, der auf dem Wasser gehen kann" vermarktete.

Freeth brachte den Surfsport nach Amerika – und Duke Kahanamoku in die ganze Welt. Kahanamoku, waschechter Hawaiianer und hoch begabter Wassersportler, war ebenfalls einer der Waikiki Beach Boys und 1905 eines der Gründungsmitglieder des Surfclubs *Hui Nalu* (Club der Wellen). Als junger Mann brach er etliche Weltrekorde im Schwimmen und reiste 1912 mit dem amerikanischen Schwimmteam zur Olympiade nach Stockholm. Unterwegs sorgte er mit seinen Surfvorführungen in Santa Monica und Corona del Mar, Kalifornien, für Schlagzeilen. Seine zahlreichen Olympiasiege machten ihn zum inoffiziellen Botschafter Hawaiis, und er nutzte seinen hohen Bekanntheitsgrad, um den Rest seines Lebens um die Welt zu reisen und für den Surfsport zu werben.

Bilder vom Wellenreiten wurden nun allgegenwärtig: Prominente standen am Waikiki Beach mit Surfbrettern für die Fotografen Modell, amerikanische Zeitschriften brachten Bilder von Surfern (oder Modellen, die als Surfer posierten) auf den Titelblättern, und überall auf Hawaii bekam man Surf-Souvenirs in allen Formen und Farben.

Als das Surfen sich immer größerer Beliebtheit erfreute, entwickelte sich Kalifornien zum nächsten großen Surfspot. Der Surfer Tom Blake war einer der Ausrichter der ersten „Pacific Coast Surfriding-Championships" im Jahre 1928, die er mit seinem hohlen, selbst gebauten Surfbrett gewann. Unter jungen Sportlern bildete sich überall an der Pazifikküste ein cooler Surfing-Lifestyle heraus; sie entwarfen ihre eigenen Boards und übernahmen die gelassene Lebenseinstellung der Hawaiianer. In den dreißiger und vierziger Jahren blieben

Magazine cover, 1965

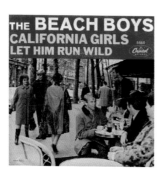

die Surfer zwar eher unauffällig, wurden in der Presse jedoch mehr und mehr als unangepasste Lebenskünstler dargestellt. Fotografen wie John „Doc" Ball hielten die frühen, unschuldigen Jahre dieses Sports in Bildern fest und führten der Welt damit einen Lebensstil vor, der später immer wieder beneidet und kopiert werden sollte.

Nach dem Zweiten Weltkrieg verwandelte sich das Surfbrett von einer unhandlichen Redwood-Planke in ein stromlinienförmiges Sportgerät – leichtgewichtiges Balsaholz, Kunstharz und Glasfaser machten es möglich – und die Surfer selbst bastelten unermüdlich an Form, Gewicht und Manövrierfähigkeit des Bretts. Das Wellenreiten wurde zum Populärsport. Surfer galten als unkonventionelle Freidenker, und die Bilderflut in den Medien trug dazu bei, dass der Surfsport in der Nachkriegszeit zum Lebensstil wurde.

Die Erschließung Hawaiis für den Massentourismus Ende der fünfziger Jahre setzte der Ruhe dort ein Ende und machte Tausende von Besuchern mit dem Wellenreiten bekannt. Am anderen Ende des Pazifiks begann mit der Einführung der leichtgewichtigen Balsabretter der Aufstieg Australiens zum dritten Surferparadies. Der Film *Gidget,* der drei Jahre später herauskam, eine Hollywood-Version der unschuldigen Surfabenteuer der sechzehnjährigen Kathy Kohner in Malibu Beach, schlug hohe Wellen und veränderte das Image des Sports für immer. Als Kalifornien Ende der Fünfziger zum Geburtsort diverser Jugendkulturen wurde, war das Surfen in den Unterhaltungsmedien omnipräsent – von den Megahits der Beach Boys bis hin zu den harmlosen Strandfilmen mit Annette Funicello und Frankie Avalon.

Bilder vom Surfen erschienen auf Plattenhüllen und in der Werbung (und bewarben so ziemlich alles außer dem Wellenreiten selbst), und Surfbretter sowie die zugehörigen Shorts wurden zu Massenprodukten. Viele ernsthafte Surfer ärgerten sich über die Kommerzialisierung ihres Sports und die überfüllten Strände. Ende der sechziger Jahre nahmen gesponserte Wettbewerbe und Drogen dem Sport endgültig seine Unschuld. Später daraus hervorgegangene Sportarten wie Windsurfen, Skateboarden und Snowboarden entwickelten ihre jeweils eigenen verwandten Subkulturen, jede mit ihren eigenen Trends, eigener Sprache und eigener Ästhetik. In den Achtzigern wurde das Wellenreiten durch große Werbeverträge der Sportler und einen boomenden Markt für Freizeitkleidung weiter kommerzialisiert.

Trotz des Konflikts zwischen Kommerzialisierung und der persönlichen Jagd nach der perfekten Welle ist der Surfsport nach wie vor für eine weltweite Anhängerschaft von Aktiven und Bewunderern eine Quelle der Inspiration. Das Surfen steht für den Traum vom alternativen Lebensstil, für endlose Sommer und die magische Anziehungskraft der Welle und gilt bis heute als Symbol für individuelle Freiheit.

Sensation surf

Si aucun écrit ne retrace les premières tentatives de l'homme pour dompter les vagues, il est généralement admis que le surf est né dans le Pacifique Sud il y a plus de quatre mille ans. Sport de loisir, il se pratique alors à plat ventre ou à genoux, sur un tronc d'arbre, des roseaux, etc. Ce n'est que vers 1000 apr. J.-C. que les surfeurs de l'archipel de Hawaii, commencent à se mettre debout sur les vagues. Le surf trouve ses adeptes parmi le peuple et la noblesse, et le roi Kamehameha Ier n'hésite pas à réaliser de véritables prouesses sur sa planche pour asseoir son statut social, pratique courante dans les îles à cette époque.

Le surf fait son apparition en Occident en 1779, dans les écrits du lieutenant James King, membre de l'expédition du capitaine James Cook qui a débarqué à Hawaii l'année précédente. Son récit décrit un passe-temps exotique et original très apprécié de la population locale. Avec l'arrivée des Européens, Hawaii devient un carrefour commercial stratégique du Pacifique. Baleiniers, marchands et vagabonds découvrent bientôt ce coin de paradis. L'arrivée des missionnaires, en revanche, nuit beaucoup à la pratique du surf. Les calvinistes, arrivés d'Angleterre en 1821, balayent nombre de traditions locales, la nudité, le plaisir et la légèreté étant peu compatibles avec leur foi. C'est ainsi que le surf, et une grande partie de la culture hawaiienne, ont bien failli disparaître au XIXe siècle. Et c'est seulement grâce à quelques autochtones et à l'intérêt de touristes comme Mark Twain, qui relate sa propre expérience dans *À la dure* (1872), que le surf échappe à la disparition totale.

Au début du XXe siècle, les États-Unis annexent les îles Hawaii. Les transports entre le continent et les îles s'améliorent et des magazines comme *Paradise of the Pacific* font leur apparition. Les descriptions de la vie dans les îles font la part belle au surf pour inciter les touristes à embarquer sur les grands paquebots.

Cependant, la culture du surf ne renaît véritablement qu'avec l'émergence de deux grandes figures mythiques : George Freeth, qui introduit ce sport sur le continent, et Duke Kahanamoku, considéré comme le père du surf moderne. George Freeth, fils d'un marin irlandais et d'une Hawaiienne, fait partie d'un groupe de surfeurs qui a investi la plage de Waikiki. En 1907, il rencontre Jack London, en vacances à Honolulu avec son épouse. L'écrivain américain, impressionné par les exploits du jeune homme, rédige un article publié dans un magazine largement diffusé, *Woman's Home Companion*. George Freeth, auréolé d'une relative célébrité, gagne le sud de la Californie où il devient maître nageur et sauveteur.

Movie still, from
Turnabout, 1940

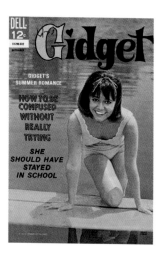

Comic book cover, 1966

Ses démonstrations au large de la plage de Venice, où il vit et travaille, soulèvent l'enthousiasme des foules. Il ne tarde pas à être employé par Henry Huntington, magnat des chemins de fer, promoteur immobilier et propriétaire d'un complexe à proximité de Redondo Beach.

C'est donc George Freeth qui importe le surf sur le continent américain, mais c'est à Duke Kahanamoku que l'on doit de l'avoir fait découvrir au monde. D'origine hawaiienne, cet athlète accompli fréquente également la plage de Waikiki et participe à la création du club de surf *Hui Nalu* (le Club des Vagues) en 1905. Très jeune, il commence à battre les records du monde de natation, et en 1912, il rejoint l'équipe américaine candidate aux Jeux Olympiques de Stockholm et ne manque pas de faire sensation avec des démonstrations de surf à Santa Monica et à Corona del Mar, en Californie. Les médailles d'or qu'il remporte aux Jeux font de lui l'ambassadeur non officiel de Hawaii, et la renommée dont il bénéficie désormais lui permet de consacrer sa vie à la promotion du surf dans le monde entier.

Avec le siècle nouveau, les images de surf dépassent le simple cadre de la promotion des îles. Des vedettes se mettent à poser sur la plage de Waikiki, une planche à la main, ou sur l'eau, en pleine action. Les magazines américains publient en couverture des photos de surfeurs (ou de mannequins habillés en surfeurs) et les souvenirs vendus à Hawaii jouent sur ce nouvel engouement. Petit à petit, le surf gagne en notoriété et la Californie devient la deuxième terre de prédilection pour la pratique de ce sport. En 1928, le surfeur Tom Blake, originaire du Wisconsin, participe à l'organisation, à Corona del Mar, des premiers championnats de surf de la côte Pacifique, qu'il remporte sur une planche creuse qu'il a lui-même construite. Sur la côte, des groupes de jeunes surfeurs adoptent un mode de vie particulier ; ils fabriquent eux-mêmes leurs planches et s'inspirent de la manière d'être décontractée des Hawaiiens. Malgré leur discrétion, les surfeurs des années 1930 et 1940 sont décrits dans la presse comme des sportifs anticonformistes. Certains photographes spécialisés comme John « Doc » Ball ont immortalisé cet âge d'or du surf californien, révélant et plébiscitant ainsi un mode de vie qui allait être envié et imité de longues années durant.

Après la Seconde Guerre mondiale, les innovations techniques transforment la pratique

du surf : les planches de séquoia peu pratiques laissent la place à des planches aux lignes pures conçues pour fendre les vagues, tandis que les surfeurs ne cessent de vouloir améliorer leur matériel. La fabrication des planches est facilitée grâce à l'utilisation du balsa, bois très léger, de la résine et de la fibre de verre. Le surf se démocratise et ses adeptes se multiplient.

À la fin des années 1950, le développement des voyages en avion met fin au relatif isolement de l'archipel. Les touristes débarquent en masse à Hawaii et découvrent le surf. L'Australie devient le troisième haut lieu du surf avec l'apparition, en 1956, des planches en balsa, beaucoup plus légères. Trois ans plus tard, *Gidget*, film hollywoodien inspiré de la vie de Kathy Kohner, jeune surfeuse de seize ans, célèbre pour ses exploits sur la plage de Malibu, fait un tabac dans les salles et change pour toujours le regard porté sur le surf. La Californie devient la Mecque de la jeunesse et le surf est omniprésent dans les médias, des Beach Boys aux films édulcorés avec Annette Funicello et Frankie Avalon.

La publicité et l'industrie du disque usent et abusent des photos de surfeurs : elles vendent absolument tout et n'importe quoi grâce au surf, mais rien qui ait un rapport avec le sport lui-même. Planches et vêtements de surf envahissent le marché. À la fin des années 1960, l'omniprésence des sponsors et la fréquence des problèmes de drogue entachent encore davantage l'image d'un sport qui a définitivement perdu son innocence. Les sports dérivés (planche à voile, skateboard, snowboard) donnent naissance à des sous-cultures ayant chacune un langage, un style graphique et des tendances propres. Dans les années 1980, les sportifs signent d'importants contrats publicitaires, le marché du *sportswear* explose et le surf n'en devient que plus commercial.

Dans cet éternel combat entre marketing et amour des vagues, le surf compte toujours de nombreux adeptes et admirateurs. Bercé par un mode de vie alternatif et par les douces images que suscitent l'été perpétuel et la quête de la vague idéale, le surfeur reste l'un des plus grands symboles de liberté individuelle.

Tourist photo stage,
Venice, California,
ca. 1980

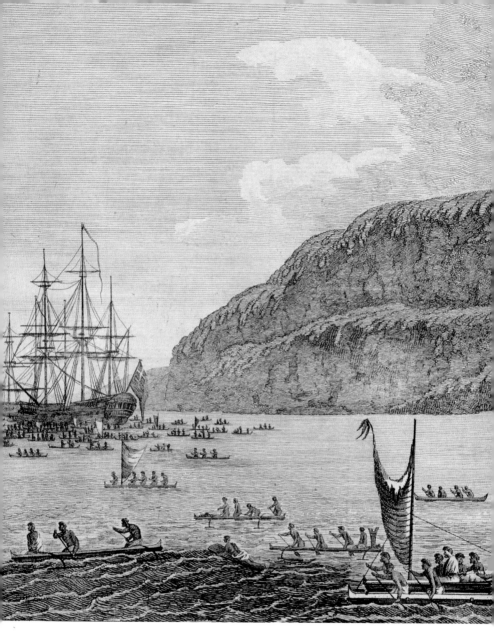

A View of Karakakooa in Owyhee, engraving, John Weber, 1784

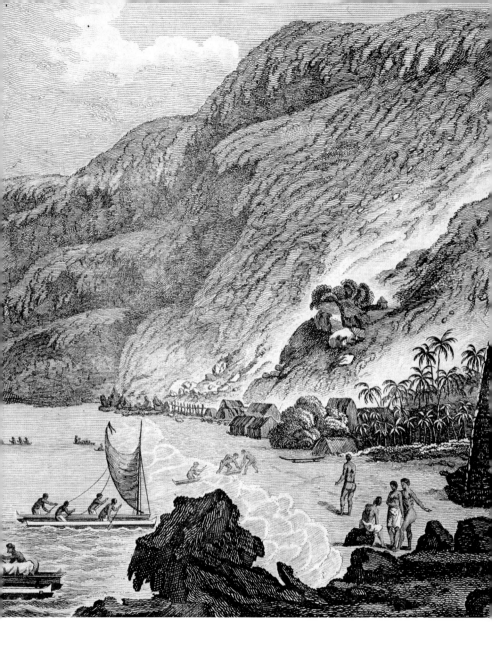

13

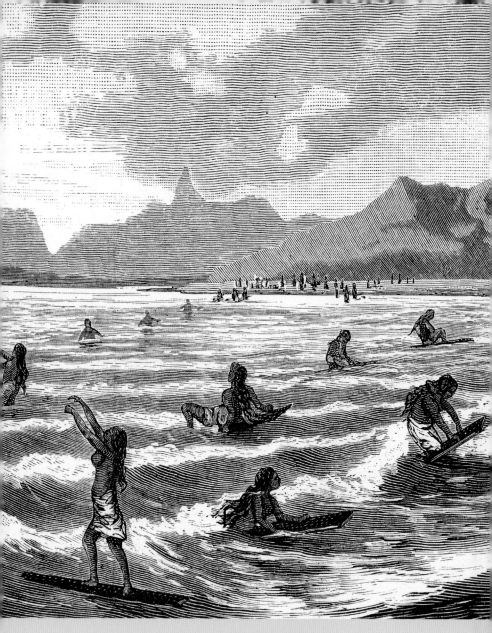

Jeux Haviens, engraving, E. Riou, 1873
▶ *Surf Swimming by Sandwich Islanders*, engraving, anonymous, 1872

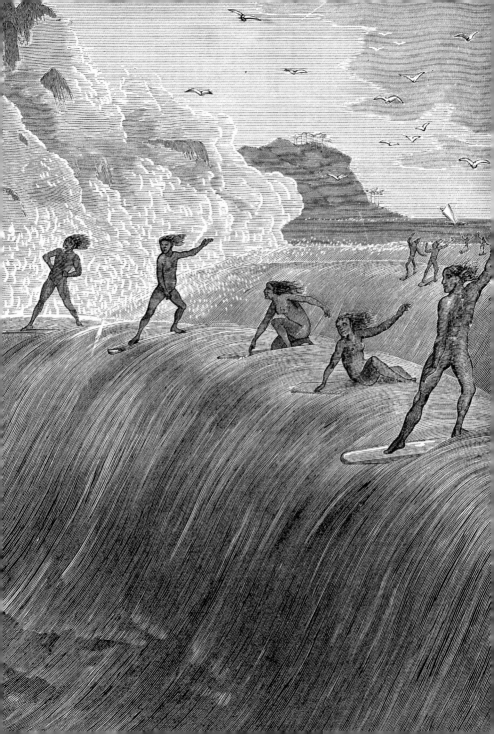

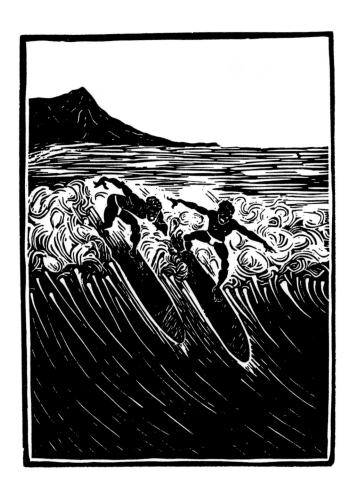

Untitled, woodcut, O. B. Patterson, 1960
▶ Untitled, woodcut, anonymous, ca. 1938

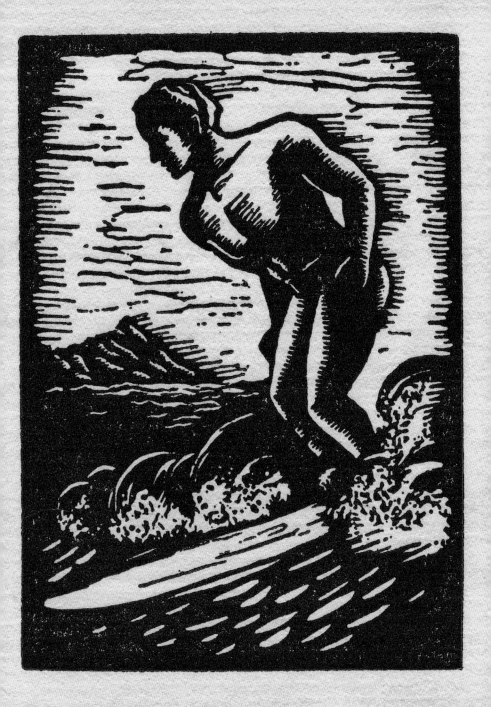

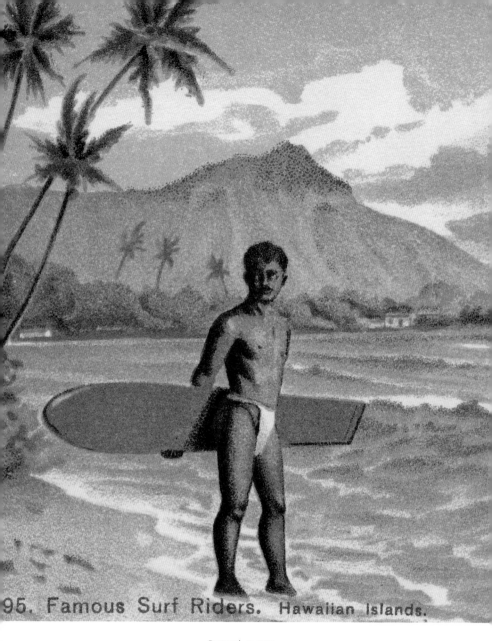

95. Famous Surf Riders. Hawaiian Islands.

Postcard, ca. 1911

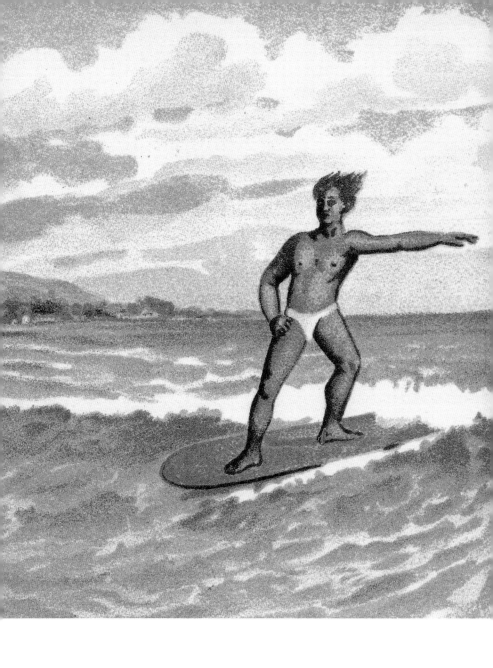

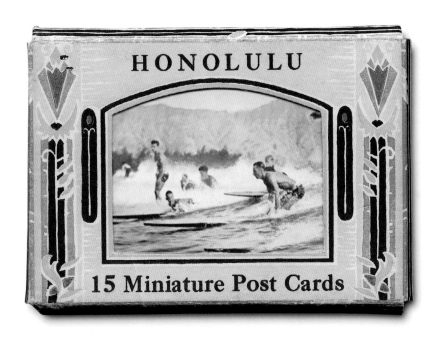

Souvenir postcard pack, ca. 1935
▶ Miscellaneous postcards, 1930s

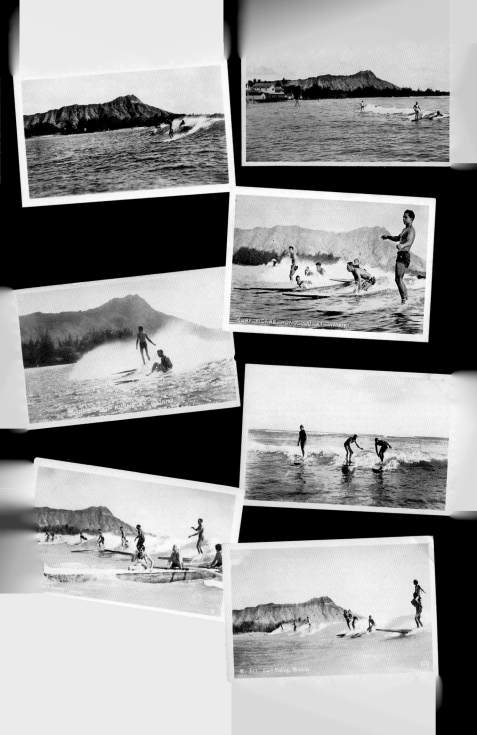

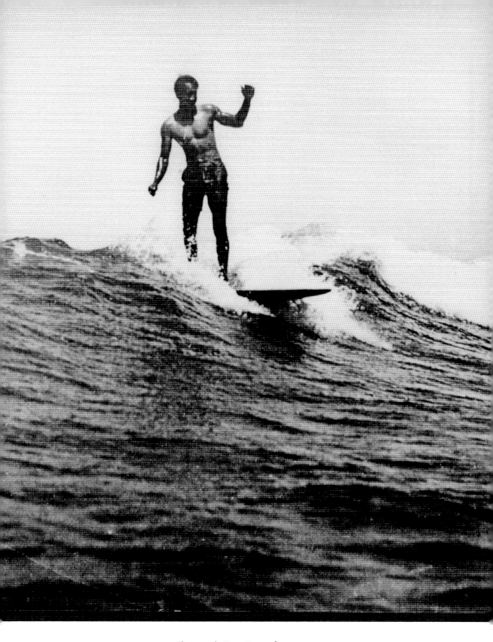

Photograph, Hawaiian surfer, ca. 1932

Tourist brochure, 1920s

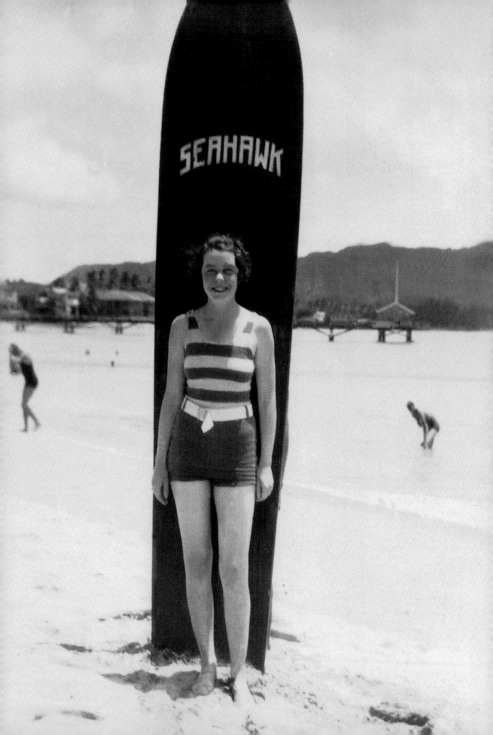

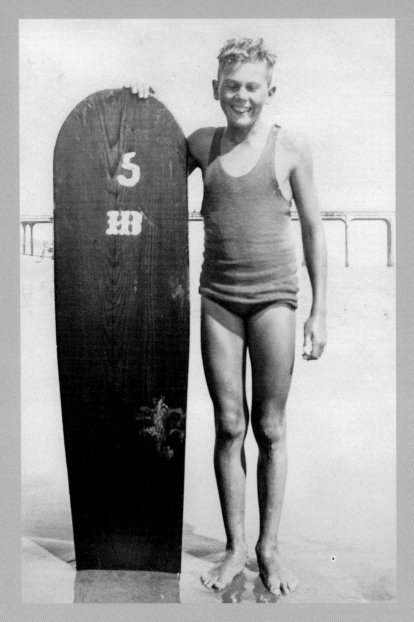

Snapshot, Waikiki, Hawai'i, ca. 1922
◄ Snapshot, Hermosa Beach, California, ca. 1933

Children's book illustration, from *Kimo*, 1928

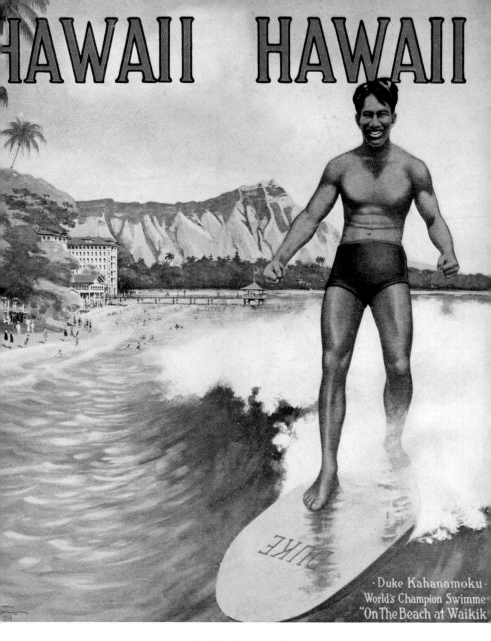

Tourist brochure, ca. 1928

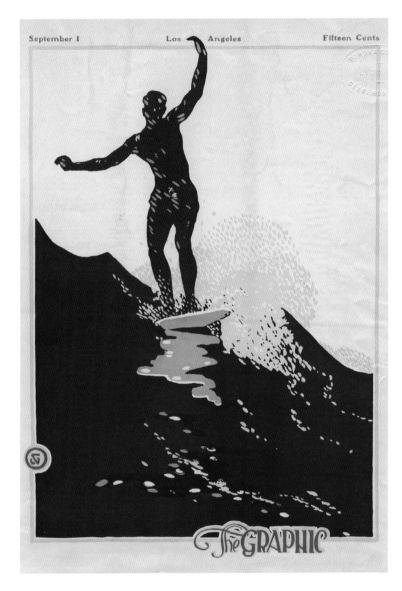

The GRAPHIC

Magazine cover, ca. 1910
▶ Magazine cover, 1919

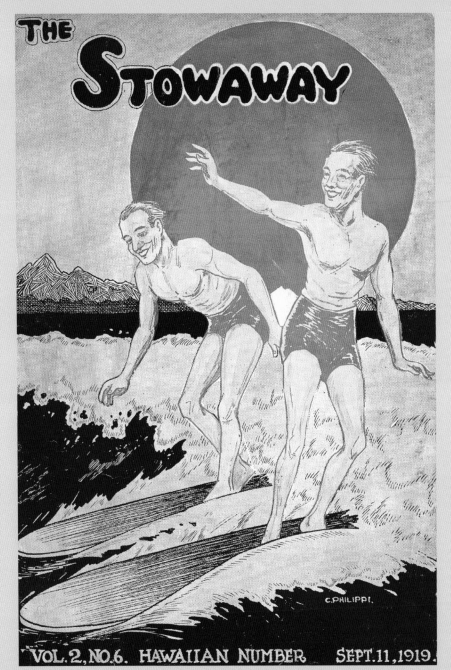

THE STOWAWAY

VOL. 2, NO. 6. HAWAIIAN NUMBER SEPT. 11, 1919.

C. PHILIPPI.

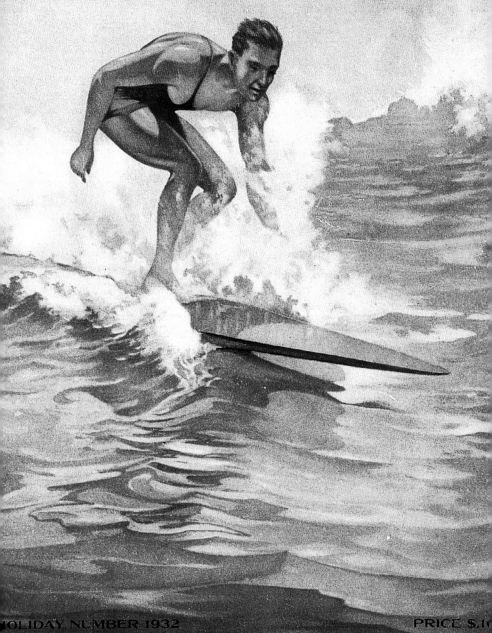

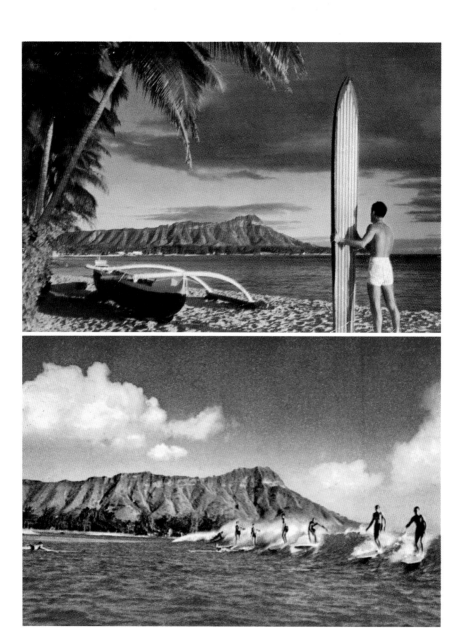

top: Postcard, ca. 1938
bottom: Postcard, ca. 1940
◄ Magazine cover, 1932

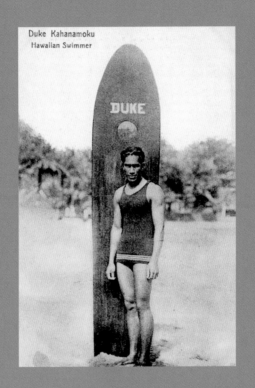

Postcard, ca. 1922

Hobie Alter

John "Doc" Ball

Tom Blake

Bruce Brown

Lance Carson

Mickey Dora

Phil Edwards

George Freeth

Margo Godfrey

Joyce Hoffman

SURF LEGENDS

Hap Jacobs

Duke Kahanamoku

Rabbit Kekai

Greg Noll

David Nuuhiwa

John Severson

Kelly Slater

Jock Sutherland

Butch Van Artsdalen

Dewey Weber

Nat Young

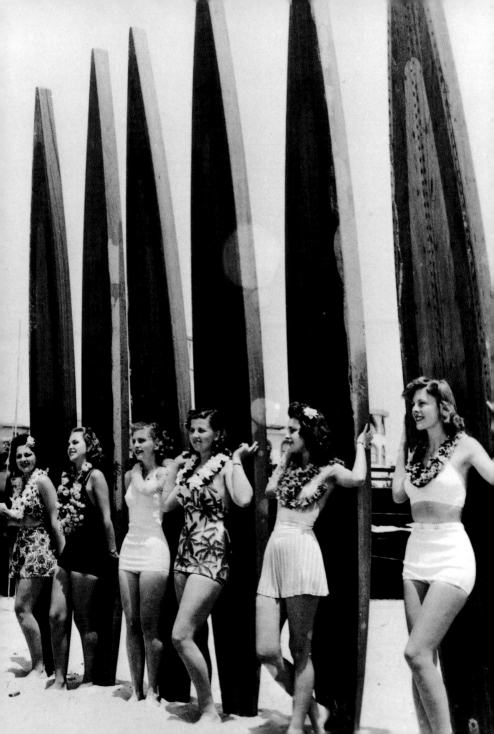

Valspar—the Varnish of countless uses—

DUKE KAHANAMOKU of Hawaii, famous athlete, expert on the surf-board and world champion 100-metre swimmer has discovered still another use for Valspar. Duke Kahanamoku writes:

Honolulu, T. H., May 3, 1921
"Have used Valspar on my surf-boards for several years, and find that it preserves the wood, because it is waterproof and prevents the water from soaking in. No matter how long the board is used in the water, the Valspar is not affected and does not change color." DUKE KAHANAMOKU.

Valspar is durable, easy to apply, weatherproof and *waterproof*— "the Varnish that won't turn white."

Valspar's well-known uses—on floors, furniture, woodwork, linoleum, airplanes, boats and railroad trains—are supplemented by countless others such as

Baby Carriages
Window-Screens
Trunks
Hand Luggage
Wicker Furniture
Refrigerators
Fireless Cookers
Draining Boards
Boots and Shoes

Golf Clubs
Tents
Fishing Rods
Tennis Rackets
Oilskins
Gun Stocks
Snow Shoes
and Skis
Etc., etc.

In fact, anything that's worth varnishing is worth Valsparring.

Don't overlook the coupon below.

VALENTINE & COMPANY

Largest Manufacturers of High Grade Varnishes in the World—Established 1832

New York Chicago Boston Toronto London Paris Amsterdam
W. P. FULLER & Co., Pacific Coast

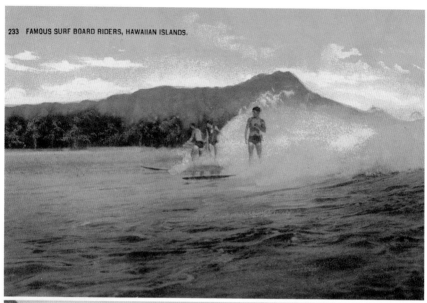

233 FAMOUS SURF BOARD RIDERS, HAWAIIAN ISLANDS.

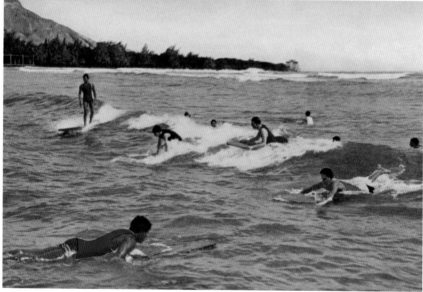

top: Postcard, ca. 1918
bottom: Postcard, ca. 1915
◄ Advertisement, 1922
◄◄ Paddleboard models, Santa Monica Pier, photograph, Adelbert Bartlett, ca. 1940
▶ Magazine cover, 1939

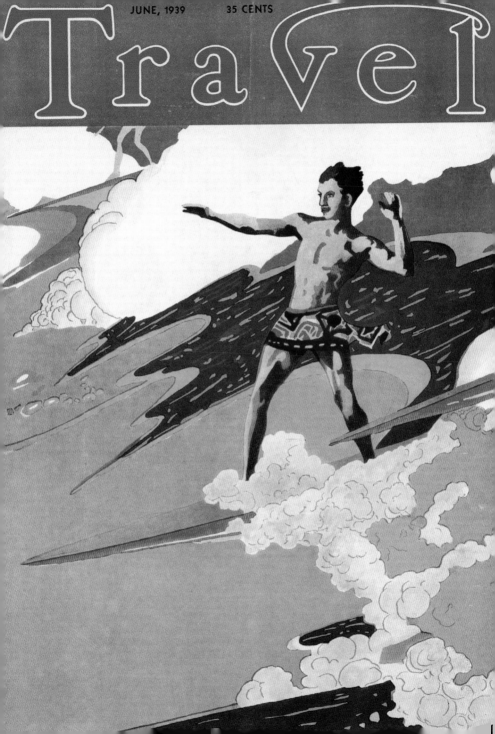

TraVel

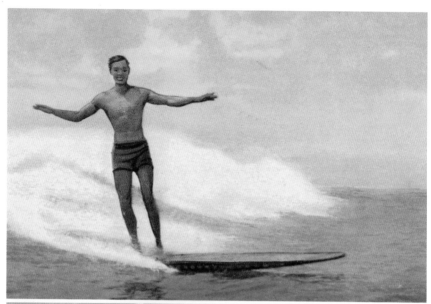

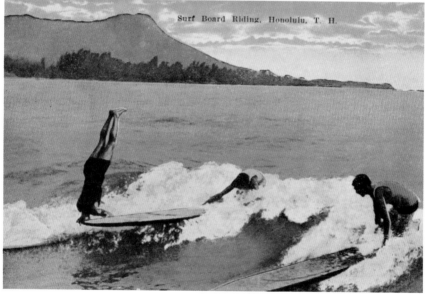

Surf Board Riding, Honolulu, T. H.

top: Postcard, ca. 1925
bottom: Postcard, ca. 1920
► Book cover, 1915

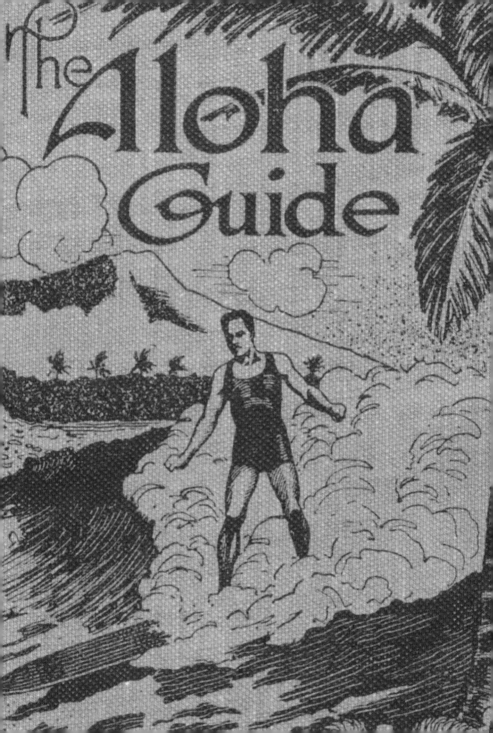

A.S. MACLEOD

HAWAIIAN ISLANDS

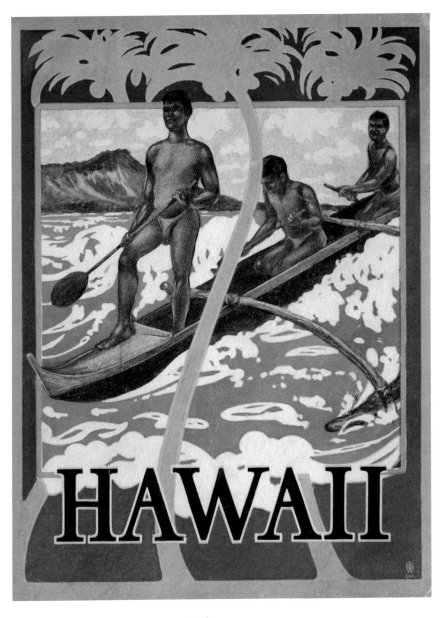

Book cover, 1903
◄ Travel brochure, ca. 1933

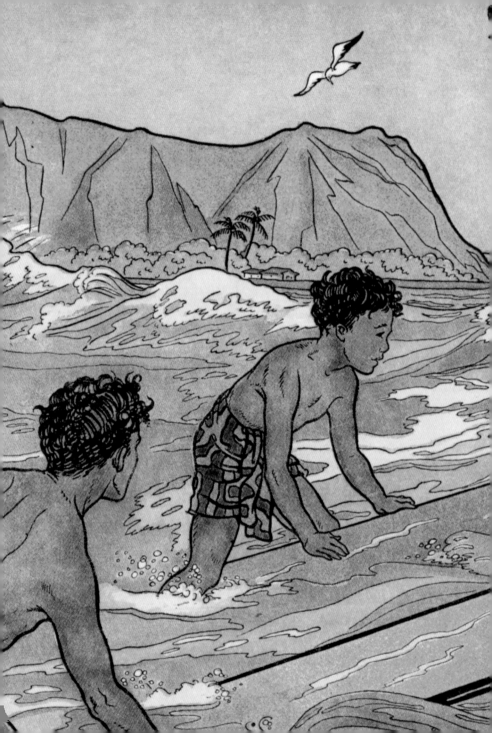

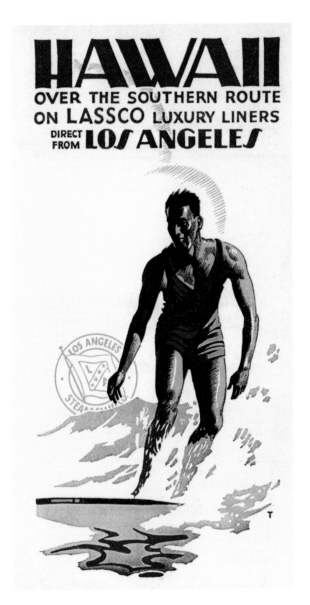

Travel brochure, ca. 1924
◄ Children's book illustration, from *Kala of Hawai'i*, 1936

HAWAIIAN

is EASY

by PAUL W. GARTNER

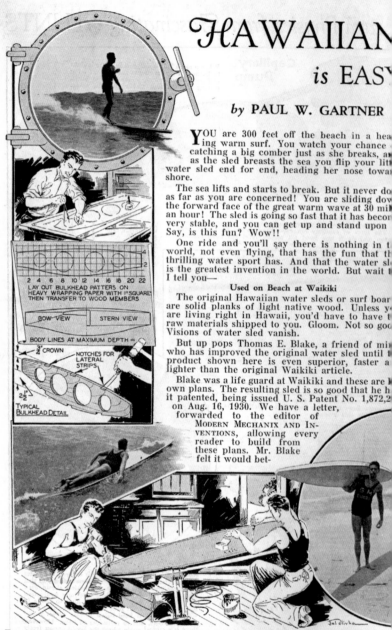

LAY OUT BULKHEAD PATTERS ON
HEAVY WRAPPING PAPER WITH I³SQUARES
THEN TRANSFER TO WOOD MEMBERS

BOW VIEW | STERN VIEW

BODY LINES AT MAXIMUM DEPTH =

¾ CROWN

NOTCHES FOR
LATERAL
STRIPS

TYPICAL
BULKHEAD DETAIL

YOU are 300 feet off the beach in a hea
ing warm surf. You watch your chance
catching a big comber just as she breaks, a
as the sled breasts the sea you flip your lit
water sled end for end, heading her nose towa
shore.

The sea lifts and starts to break. But it never do
as far as you are concerned! You are sliding dow
the forward face of the great warm wave at 30 mil
an hour! The sled is going so fast that it has becon
very stable, and you can get up and stand upon
Say, is this fun? Wow!!

One ride and you'll say there is nothing in t
world, not even flying, that has the fun that th
thrilling water sport has. And that the water sle
is the greatest invention in the world. But wait t
I tell you—

Used on Beach at Waikiki

The original Hawaiian water sleds or surf boar
are solid planks of light native wood. Unless y
are living right in Hawaii, you'd have to have t
raw materials shipped to you. Gloom. Not so goo
Visions of water sled vanish.

But up pops Thomas E. Blake, a friend of mi
who has improved the original water sled until t
product shown here is even superior, faster a
lighter than the original Waikiki article.

Blake was a life guard at Waikiki and these are h
own plans. The resulting sled is so good that he h
it patented, being issued U. S. Patent No. 1,872,2
on Aug. 16, 1930. We have a letter,
forwarded to the editor of
MODERN MECHANIX AND IN-
VENTIONS, allowing every
reader to build from
these plans. Mr. Blake
felt it would bet-

Top view: Sled coasting. Center: Laying out sections. Below: Building and using sled. Note swimming positi
The sled rides downhill on the forward face of the wave when coasting in the surf, and attains great speed. As she
left below, the sled is fine for developing a swimmer's shoulder and arm muscles, and is useful for rescue wo

WATER SLED

BUILD

...hrough arrangements with the patent
...older Modern Mechanix and Inventions
...presenting this fine piece of aquatic
...orting equipment which has many novel
...es. Build one and get a new thrill
...ding down combers at the sea shore!

...serve the aquatic world to make the plans public
...n to try to "farm" them in some other way. Of
...urse, it is understood you are not to build a sled
...sale.

New Sled Great Improvement

...The new sled is bigger and lighter than the
...waiian article.

...Increased efficiency has resulted among lifesaving
...ews on southern California beaches with the adop-
...n of this hollow surf board.

...A life guard operating a water sled can cover 100
...rds in a little more than 30 seconds, which is ap-
...oximately half the time required by an expert
...immer to negotiate that distance. And where a
...imming rescuer may face serious difficulty in
...proaching and handling a person in distress, the
...n upon the buoyant board simply pulls his subject
...oard and paddles to safety.

...The dangers of the tide rip—a treacherous current
...ich sweeps seaward along a local channel formed
...the backwash of the breakers—are minimized by
...e use of the water sled. Not infrequently a single
...e rip will find several unfortunates caught at the
same time. Upon the hollow board
a lone guard may keep afloat from
six to ten persons. In ad-
dition, the water sled is
very effective in bear-
ing a paddler seaward

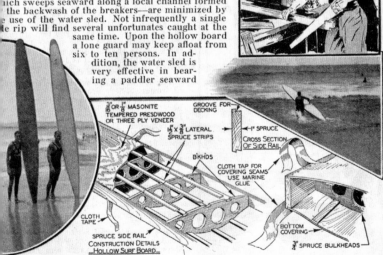

LATERAL STRIPS
1½ x ¾ SPRUCE

2½ AT END

STERN BLOCK DETAIL

NOTCHES FOR LATERAL STRIPS

PASSAGE TO AIR CHAMBER

SIDE RAIL OF 1" SPRUCE

TAPER TO 1" AT BOW

BOW BLOCK DETAIL

¾ OR 1½ MASONITE TEMPERED PRESDWOOD OR THREE PLY VENEER

GROOVE FOR DECKING

1½ x ¾ LATERAL SPRUCE STRIPS

1" SPRUCE

CROSS SECTION OF SIDE RAIL

B'KHDS

CLOTH TAP FOR COVERING SEAMS USE MARINE GLUE

BOTTOM COVERING

¾ SPRUCE BULKHEADS

CLOTH TAPE

SPRUCE SIDE RAIL CONSTRUCTION DETAILS HOLLOW SURF BOARD

...p: How sled is paddled. Right center: Launching sled in surf. Other views clearly show construction of sled.
...e bow block may be a piece of white pine and the side strips of spruce. The stern block is of spruce. The battens
...y be of any light wood which will hold fastenings well. In spite of its length, the board is light and easily handled.

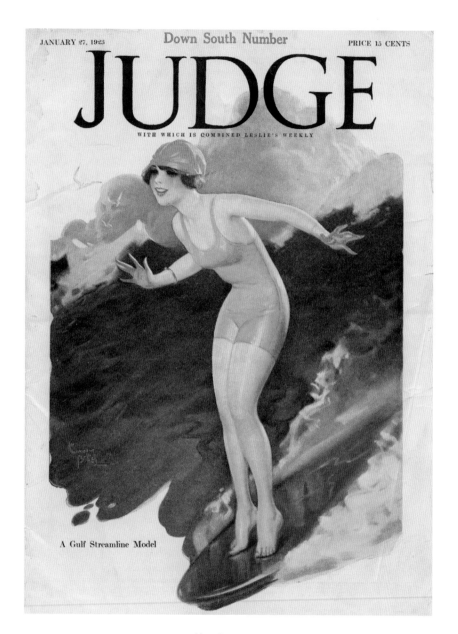

Down South Number

JUDGE

WITH WHICH IS COMBINED LESLIE'S WEEKLY

A Gulf Streamline Model

Magazine cover, 1923
◄ Magazine article, 1933

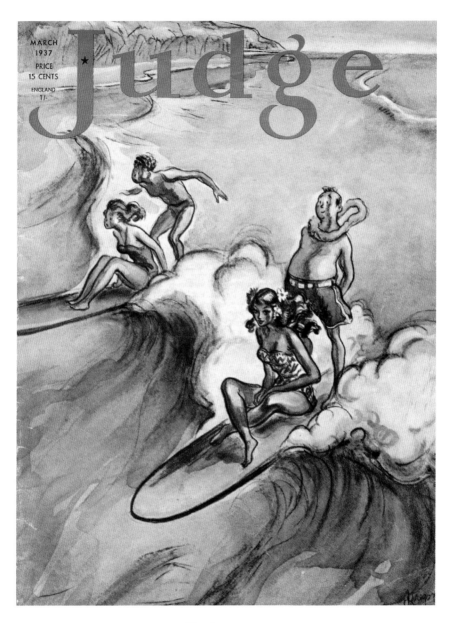

MARCH
1937
PRICE
15 CENTS
ENGLAND
1/-

Magazine cover, 1937

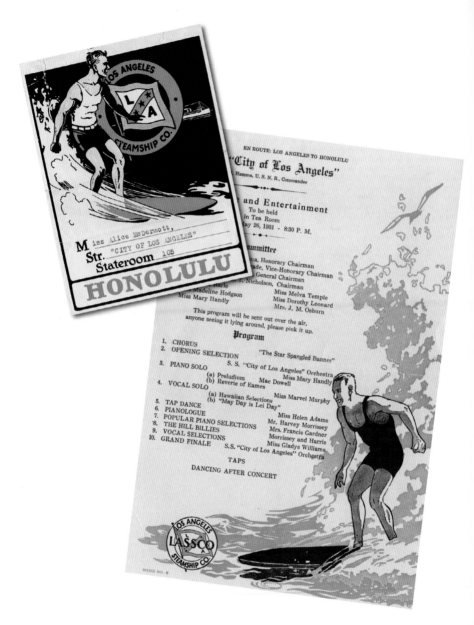

EN ROUTE: LOS ANGELES TO HONOLULU

"City of Los Angeles"

Hamma, U. S. N. R., Commander

and Entertainment

To be held
in Tea Room
ay 26, 1931 - 8:30 P. M.

ommittee

ua, Honorary Chairman
ade, Vice-Honorary Chairman
, General Chairman
, Nicholson, Chairman

Harle
Madeline Hodgson
Miss Mary Handly

Miss Melva Temple
Miss Dorothy Leonard
Mrs. J. M. Osburn

This program will be sent out over the air,
anyone seeing it lying around, please pick it up.

Program

1. CHORUS
2. OPENING SELECTION "The Star Spangled Banner"
 S. S. "City of Los Angeles" Orchestra
3. PIANO SOLO Miss Mary Handly
 (a) Preludium Mac Dowell
 (b) Reverie of Eames
4. VOCAL SOLO Miss Marvel Murphy
 (a) Hawaiian Selections
 (b) "May Day is Lei Day"
5. TAP DANCE Miss Helen Adams
6. PIANOLOGUE Mr. Harvey Morrissey
7. POPULAR PIANO SELECTIONS Mrs. Francis Gardner
8. THE HILL BILLIES Morrissey and Harris
9. VOCAL SELECTIONS Miss Gladys Williams
10. GRAND FINALE S.S. "City of Los Angeles" Orchestra

TAPS

DANCING AFTER CONCERT

LASSCO

MENU NO. 8

top: Luggage sticker, ca. 1926
bottom: Steamship program, 1931
▶ Steamship program, 1929

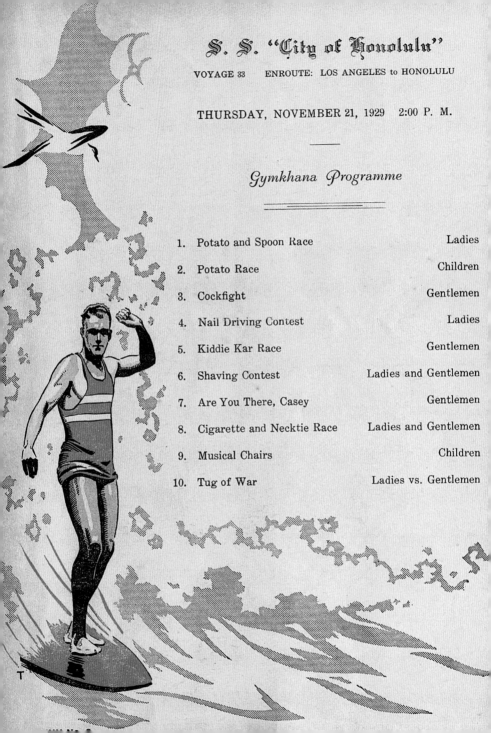

S. S. "City of Honolulu"

VOYAGE 33 ENROUTE: LOS ANGELES to HONOLULU

THURSDAY, NOVEMBER 21, 1929 2:00 P. M.

Gymkhana Programme

1.	Potato and Spoon Race	Ladies
2.	Potato Race	Children
3.	Cockfight	Gentlemen
4.	Nail Driving Contest	Ladies
5.	Kiddie Kar Race	Gentlemen
6.	Shaving Contest	Ladies and Gentlemen
7.	Are You There, Casey	Gentlemen
8.	Cigarette and Necktie Race	Ladies and Gentlemen
9.	Musical Chairs	Children
10.	Tug of War	Ladies vs. Gentlemen

Trading stamps, ca. 1940
▶ Travel brochure, ca. 1916

51

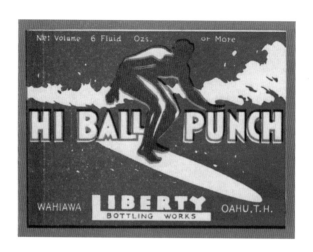

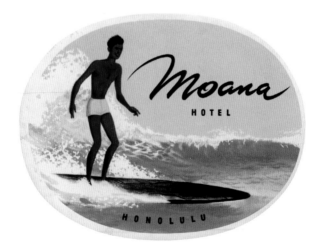

top: Soft drink label, 1930s
bottom: Luggage label, 1950s

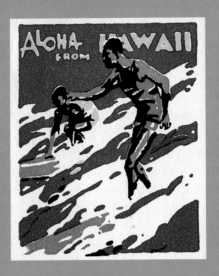

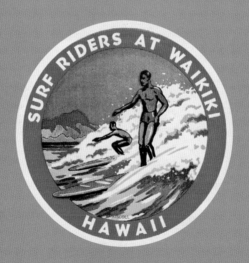

top: Poster stamp, ca. 1918
bottom: Luggage decal, ca. 1937

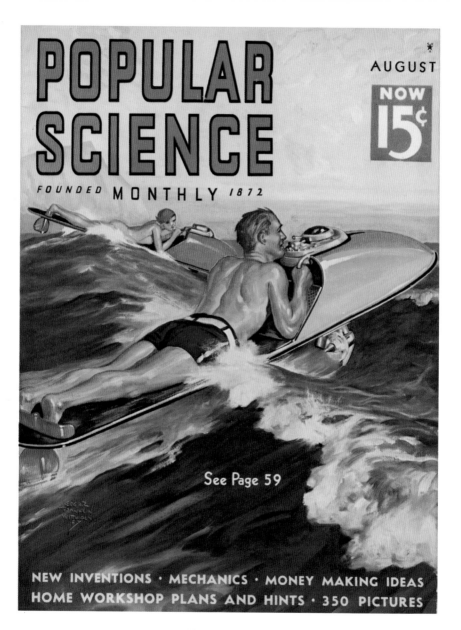

POPULAR SCIENCE

AUGUST

NOW 15¢

FOUNDED MONTHLY *1872*

See Page 59

NEW INVENTIONS · MECHANICS · MONEY MAKING IDEAS
HOME WORKSHOP PLANS AND HINTS · 350 PICTURES

Magazine cover, 1937

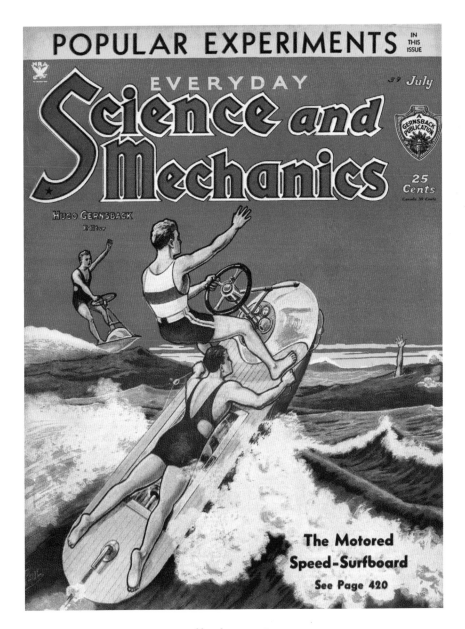

Magazine cover, 1934

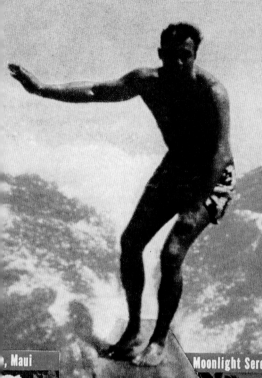

National Park, H

Kona Coast, Hawaii

, Maui

Moonlight Serenade

Lawai Beach, K

SENATOR

Exhilarating Sport

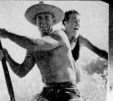

1938,
IST BUREAU

★ Hawaii, Maui, Oahu and Kauai are
four larger islands of this lovely fl

LIFE is spelled with capitals in

Hawaii

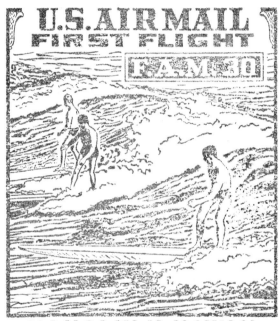

Letter postmark, 1950
◄ Magazine advertisement, 1938

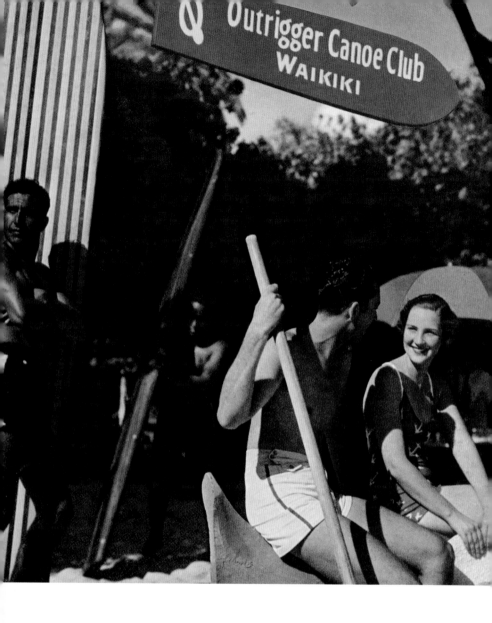

Magazine advertisement, detail, 1936
▶ Beach patrol brochure, ca. 1935

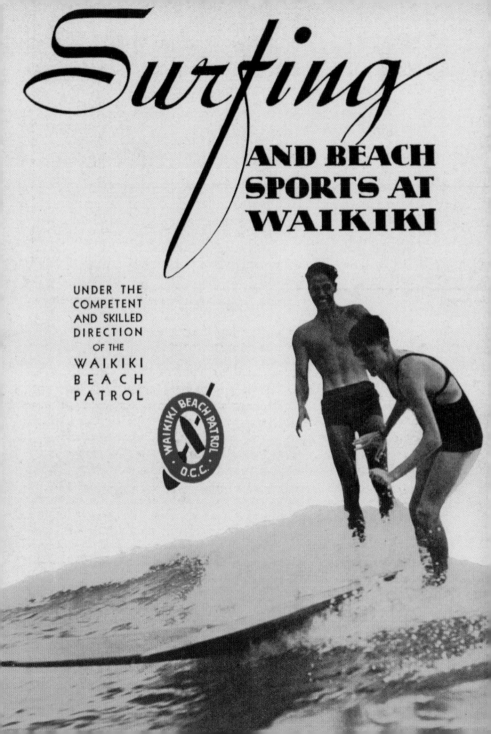

Surfing

AND BEACH SPORTS AT WAIKIKI

UNDER THE
COMPETENT
AND SKILLED
DIRECTION
OF THE
WAIKIKI
BEACH
PATROL

WAIKIKI BEACH PATROL
O.C.C.

Travel brochure, ca. 1923
▶ Poster stamp, ca. 1958
▶▶ Package label, ca. 1929

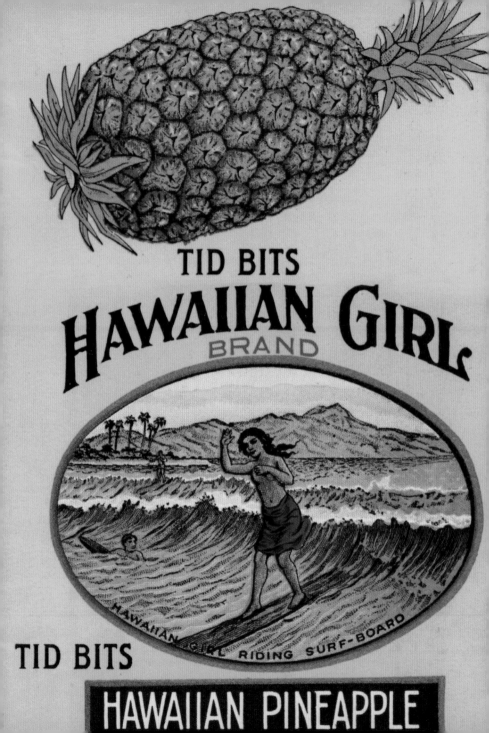

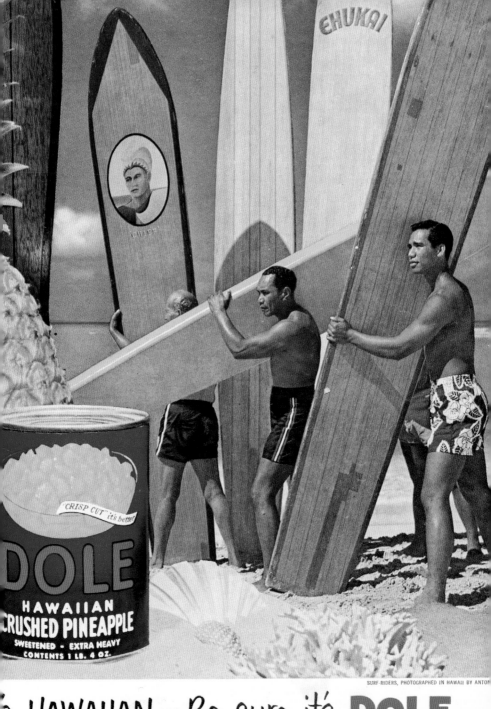

EHUKAI

"CRISP CUT" it's better

DOLE
HAWAIIAN
CRUSHED PINEAPPLE
SWEETENED · EXTRA HEAVY
CONTENTS 1 LB. 4 OZ.

s HAWAIIAN — Be sure it's DOLE

A-B-C Eliminator—Page 1005

N.S.

25 CENTS

POPULAR MECHANICS

MAGAZINE

WRITTEN SO YOU CAN UNDERSTAND IT

REG'D. TRADE MARK, GREAT BRITAIN, No. 410426 REG. U.S. PAT. OFF.

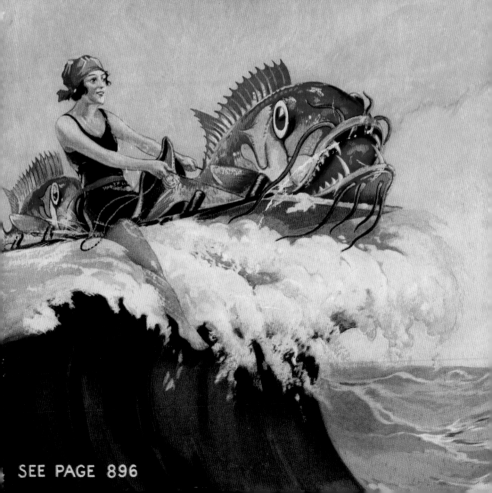

SEE PAGE 896

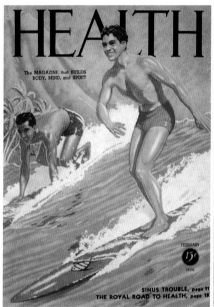

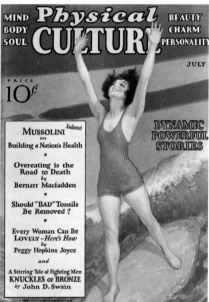

left: Magazine cover, 1936
right: Magazine cover, 1932
◀ Magazine cover, 1927
◀ ◀ Magazine advertisement, detail, ca. 1938

1000 AD *Alaia*

1000 AD *Olo*

1920s–30s **Hawaiian Hollow Paddleboard**

1930s **Waikiki Redwood**

SURFBOARD EVOLUTION

1950 **Finless Balsa**

1957 **The "Pig"**

1966 **"Da Cat"**

1967 **Shortboard Revolution**

Surfboard Evolution

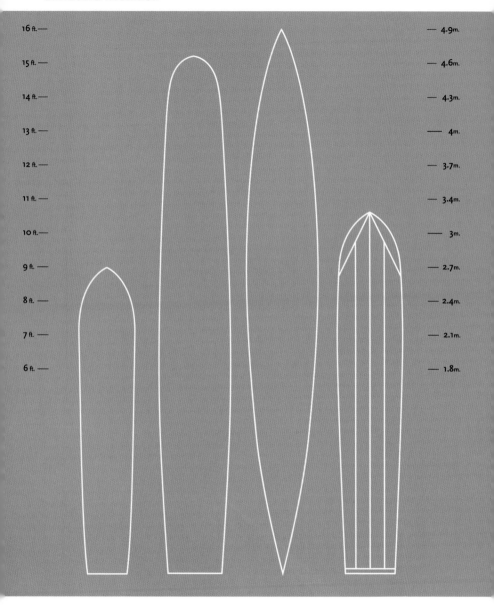

16 ft.		4.9m.
15 ft.		4.6m.
14 ft.		4.3m.
13 ft.		4m.
12 ft.		3.7m.
11 ft.		3.4m.
10 ft.		3m.
9 ft.		2.7m.
8 ft.		2.4m.
7 ft.		2.1m.
6 ft.		1.8m.

Ancient
Alaia
Wiliwili
6–9 ft.

Ancient
Olo
Koa Wood
12–16 ft.

1920s–1930s
Tom Blake "Cigar"
Paddleboard
16 ft.

1930s
Waikiki-Style
Redwood
10 ft.

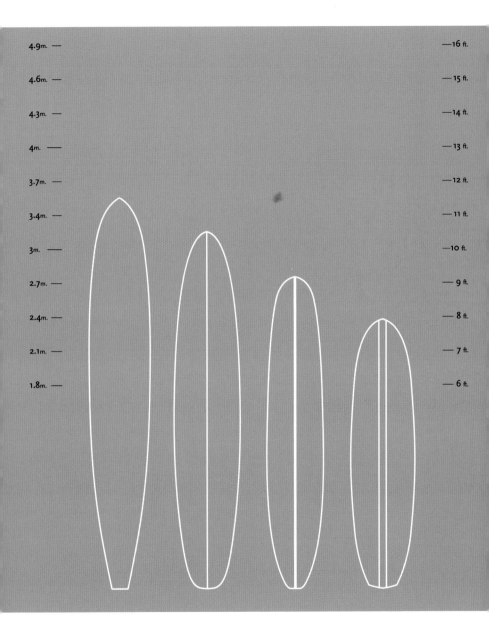

4.9m. —					—16 ft.
4.6m. —					—15 ft.
4.3m. —					—14 ft.
4m. —					—13 ft.
3.7m. —					—12 ft.
3.4m. —					—11 ft.
3m. —					—10 ft.
2.7m. —					—9 ft.
2.4m. —					—8 ft.
2.1m. —					—7 ft.
1.8m. —					—6 ft.

1950
Quigg "Hot Curl"
Finless Balsa
11 ft., 6 in.

1957–1958
Velzy-Jacobs
"Pig"
10 ft., 6 in.

1966
Greg Noll
"Da Cat"
9 ft., 2 in.

1967
Mc Tavish
"Deep V"
7 ft., 11 in.

STORIES *o*
HAWAII
FRENCH

top: Book cover, 1933
bottom: Steamship passenger list cover, ca. 1938

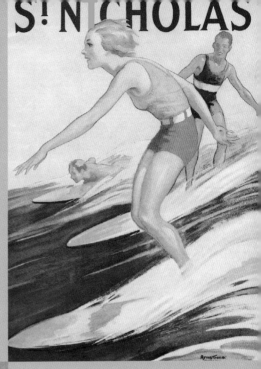

ST NICHOLAS

BAILEY TWINS
in the PHILIPPINES

top: Magazine cover, 1930
bottom: Book cover, 1930
▶ Souvenir photograph, ca. 1936

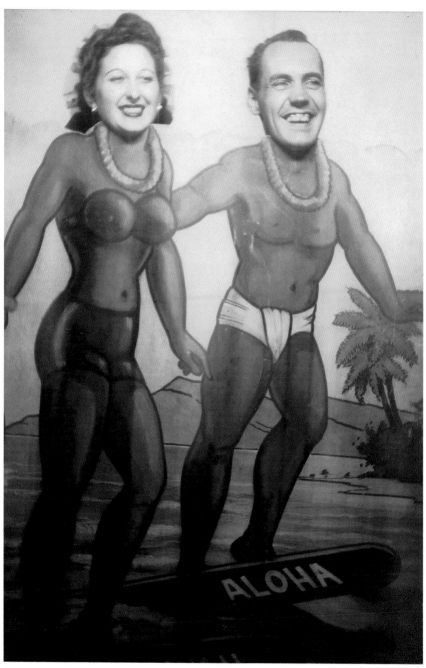

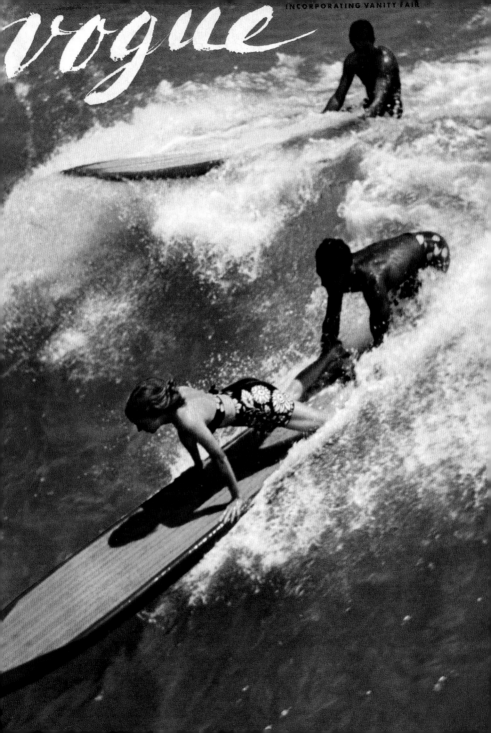

vogue

INCORPORATING VANITY FAIR

Playground of the South Seas

Travel brochure, detail, ca. 1956
◄ Magazine cover, photograph by Toni Frissell, 1938

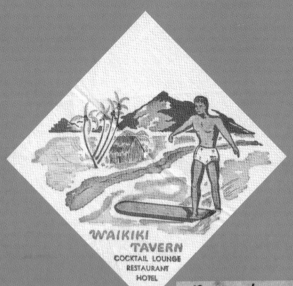

WAIKIKI
TAVERN
COCKTAIL LOUNGE
RESTAURANT
HOTEL

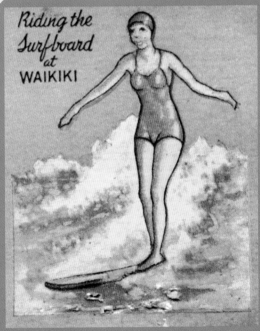

Riding the
Surfboard
at
WAIKIKI

top: Cocktail napkin, ca. 1949
bottom: Matchbook, ca. 1937

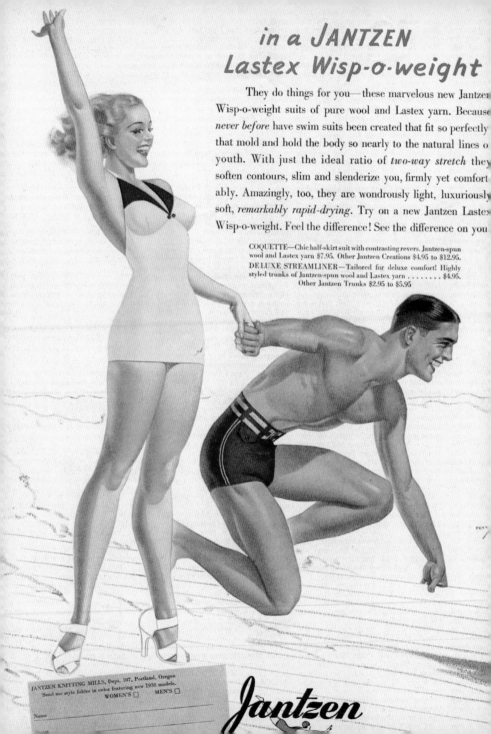

in a JANTZEN
Lastex Wisp-o-weight

They do things for you—these marvelous new Jantzen Wisp-o-weight suits of pure wool and Lastex yarn. Because *never before* have swim suits been created that fit so perfectly that mold and hold the body so nearly to the natural lines o youth. With just the ideal ratio of *two-way stretch* they soften contours, slim and slenderize you, firmly yet comfort ably. Amazingly, too, they are wondrously light, luxuriously soft, *remarkably rapid-drying*. Try on a new Jantzen Lastex Wisp-o-weight. Feel the difference! See the difference on you

COQUETTE—Chic half-skirt suit with contrasting revers. Jantzen-spun wool and Lastex yarn $7.95. Other Jantzen Creations $4.95 to $12.95.
DELUXE STREAMLINER—Tailored for deluxe comfort! Highly styled trunks of Jantzen-spun wool and Lastex yarn $4.95. Other Jantzen Trunks $2.95 to $5.95

Jantzen

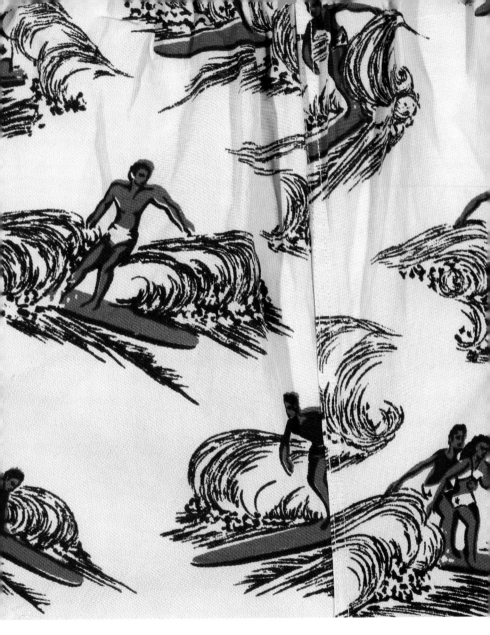

Swim trunks, detail, ca. 1940

◄ Magazine advertisement, 1938

► Travel brochure, ca. 1933

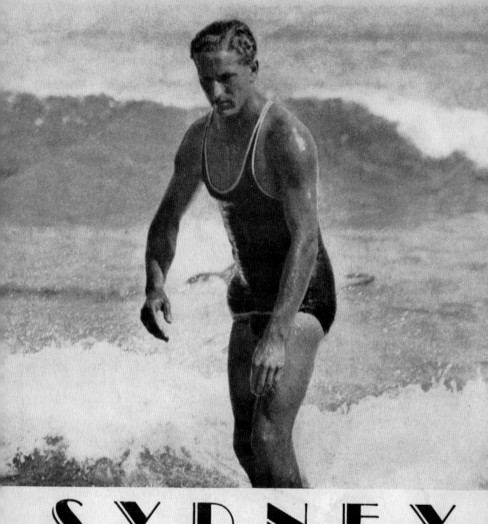

SYDNEY

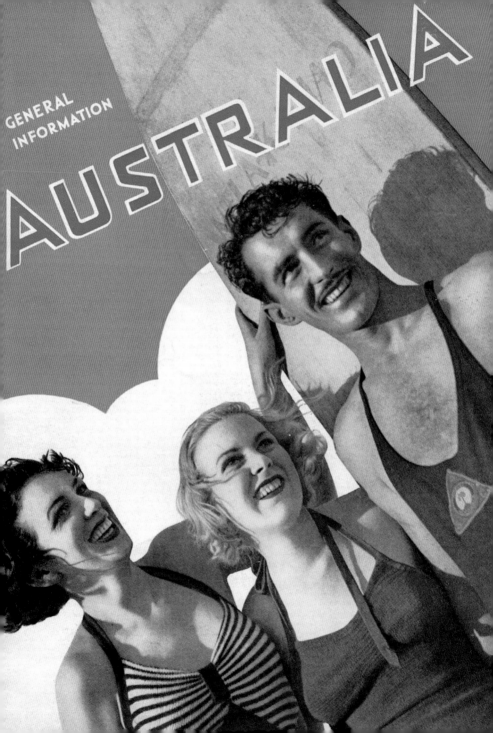

GENERAL
INFORMATION

AUSTRALIA

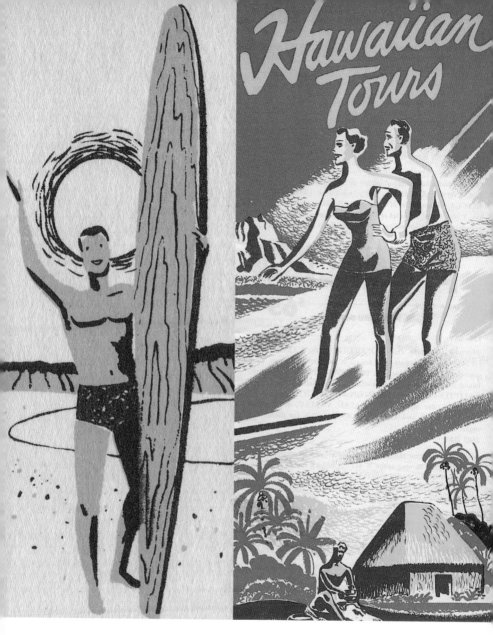

left: Travel brochure, detail, ca. 1954
right: Travel brochure, ca. 1952
◄ Travel brochure, 1938
► Travel brochure, 1964

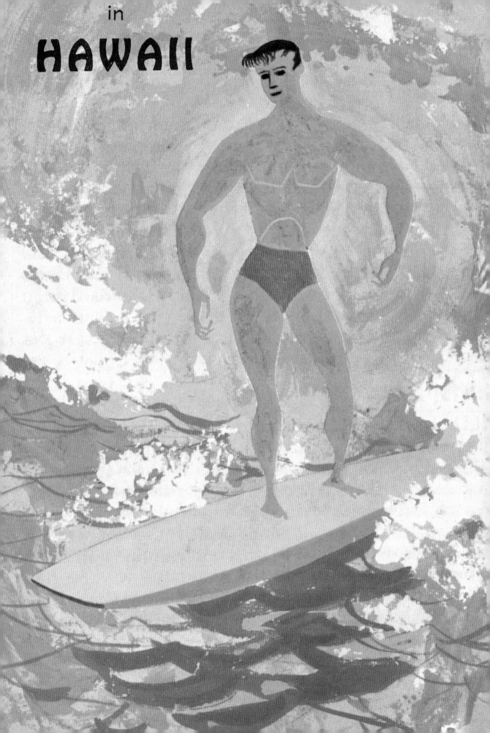

in
HAWAII

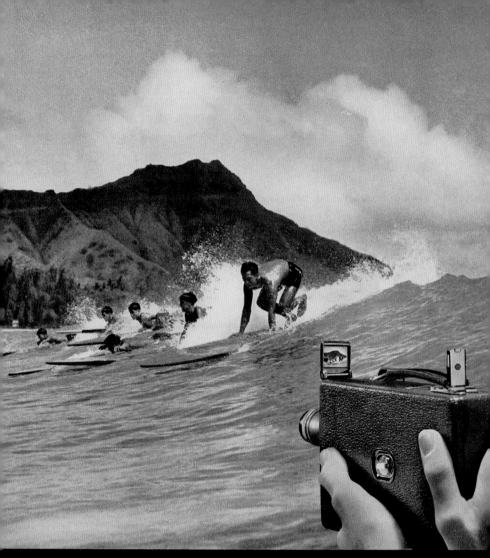

You're Making Movies with the "K" at Waikiki

Extra equipment for the "K" includes four telephoto lenses, for close-ups of distant action; the wide-angle lens, giving breadth of view in close quarters; filters for cloud effects and scenics; and the Kodacolor Adjustable Filter for gorgeous movies in full natural color.

● Bronze bodies soaring on a wave . . . this *is* the poetry of mo Your Ciné-Kodak "K" will bring away the poetry, the motion, the exotic *color* of strange places . . . for your movie screen at h No disappointments with the "K"—it's simple, yet amazingly satile. Loads with full 100 feet of 16 mm. film. Price, inclu case, from $112.50. Eastman Kodak Company, Rochester, New Y *If it isn't an Eastman, it isn't a Kodak.*

Ciné-Kodak "K"

EASTMAN'S FINEST HOME MOVIE CAME

FROM A KODACHROME ORIGINAL

Midsummer, and an indigo blue sea; a golden girl, with
lips the color of a poinsettia flower ... You get the whole
scene, with all its brilliant color and vivid motion, just
as you see it here, when you make home movies with
full-color KODACHROME FILM.

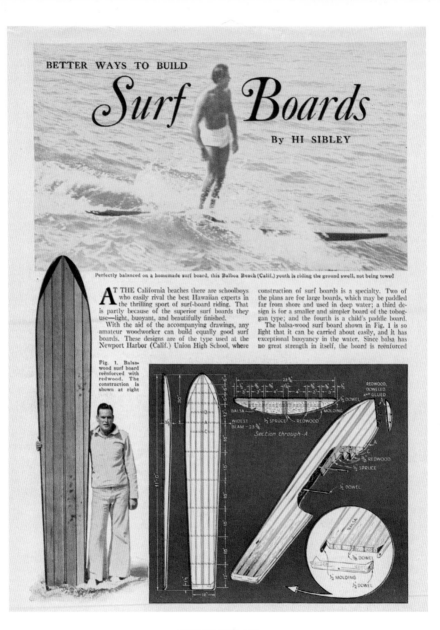

BETTER WAYS TO BUILD

Surf Boards

By HI SIBLEY

Perfectly balanced on a homemade surf board, this Balboa Beach (Calif.) youth is riding the ground swell, not being towed

AT THE California beaches there are schoolboys who easily rival the best Hawaiian experts in the thrilling sport of surf-board riding. That is partly because of the superior surf boards they use—light, buoyant, and beautifully finished.

With the aid of the accompanying drawings, any amateur woodworker can build equally good surf boards. These designs are of the type used at the Newport Harbor (Calif.) Union High School, where construction of surf boards is a specialty. Two of the plans are for large boards, which may be paddled far from shore and used in deep water; a third design is for a smaller and simpler board of the toboggan type; and the fourth is a child's paddle board.

The balsa-wood surf board shown in Fig. 1 is so light that it can be carried about easily, and it has exceptional buoyancy in the water. Since balsa has no great strength in itself, the board is reënforced

Fig. 1. Balsa-wood surf board reënforced with redwood. The construction is shown at right

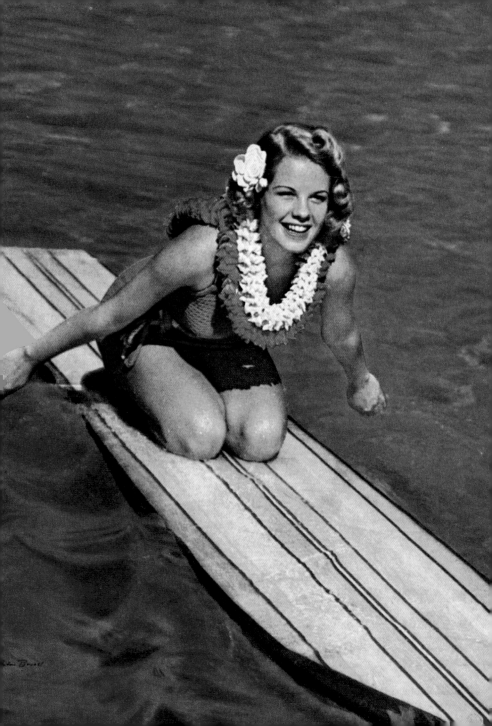

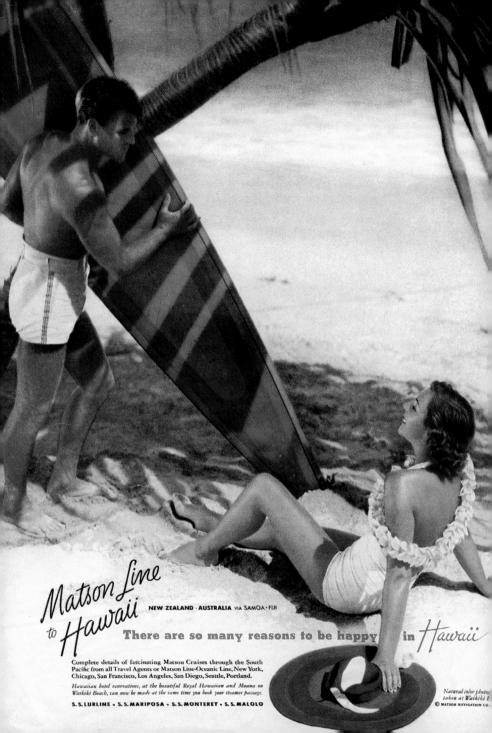

Matson Line to Hawaii

NEW ZEALAND · AUSTRALIA VIA SAMOA · FIJI

There are so many reasons to be happy in *Hawaii*

Complete details of fascinating Matson Cruises through the South
Pacific from all Travel Agents or Matson Line-Oceanic Line, New York,
Chicago, San Francisco, Los Angeles, San Diego, Seattle, Portland.

*Hawaiian hotel reservations, at the beautiful Royal Hawaiian and Moana on
Waikiki Beach, can now be made at the same time you book your steamer passage.*

S. S. LURLINE · S. S. MARIPOSA · S. S. MONTEREY · S. S. MALOLO

*Natural color photos
taken at Waikiki* l
© MATSON NAVIGATION CO.

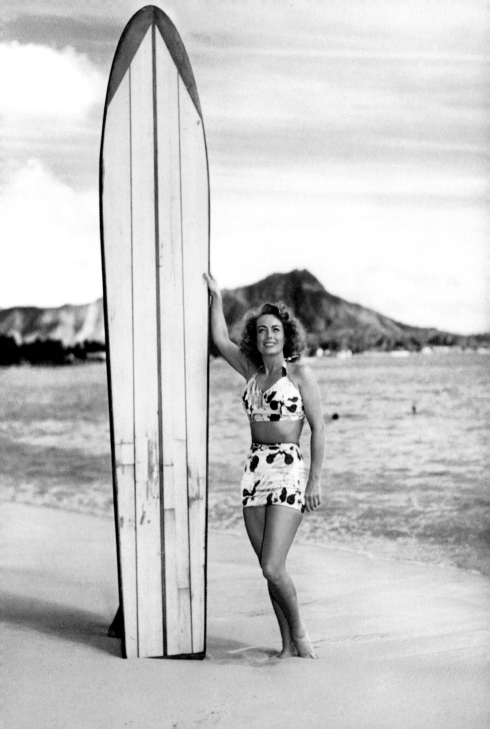

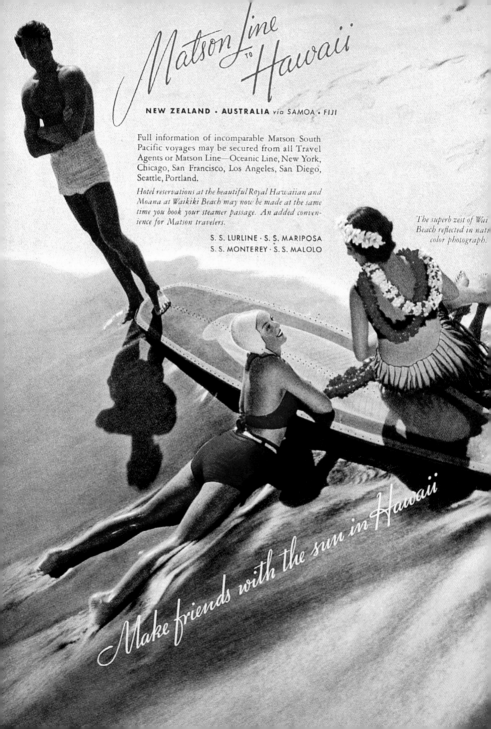

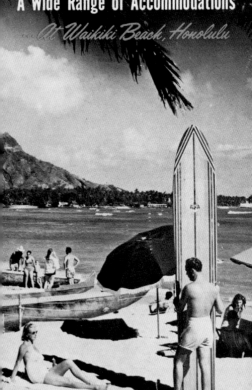

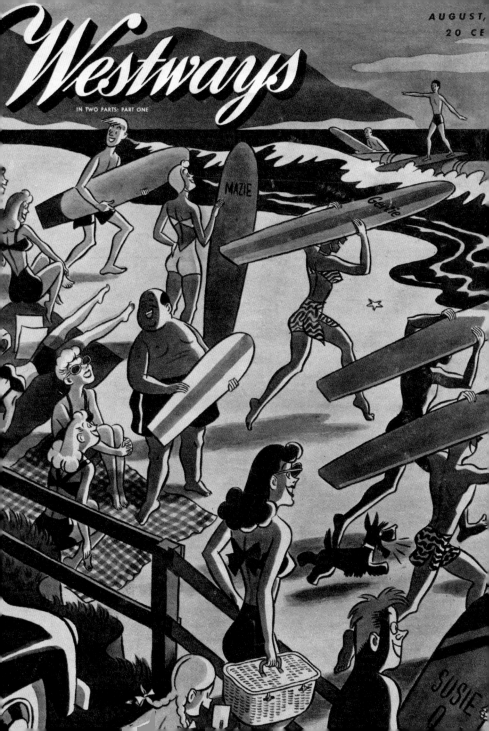

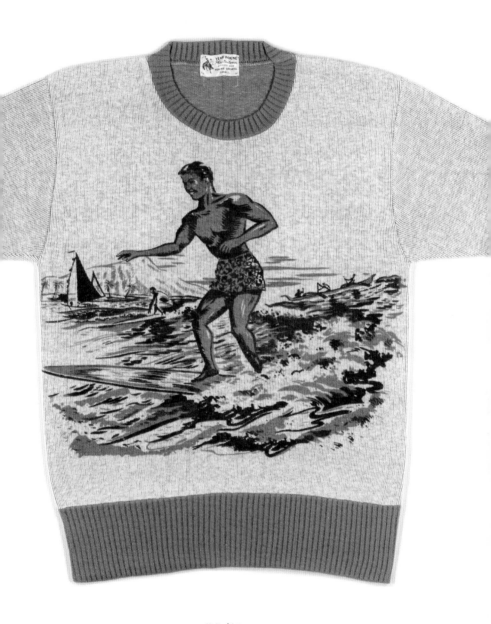

Knit shirt, ca. 1940
◄ Tablecloth pattern, detail, ca. 1939
► Travel brochure, ca. 1955
►► Travel brochure, ca. 1936

MANHATTAN BEACH
California!

WHERE LIVING ALL YEAR 'ROUND
IS VACATION EVERY DAY!

At the ocean edge of
Los Angeles County

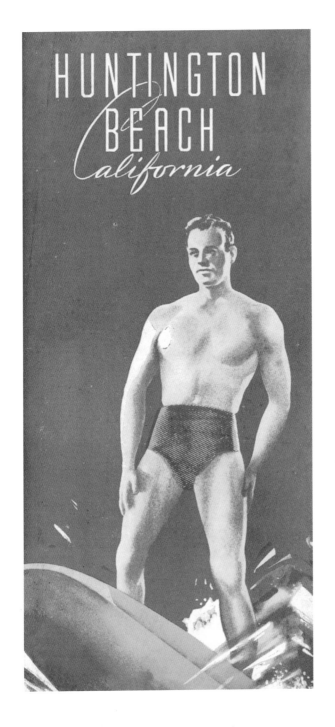

HUNTINGTON *BEACH California*

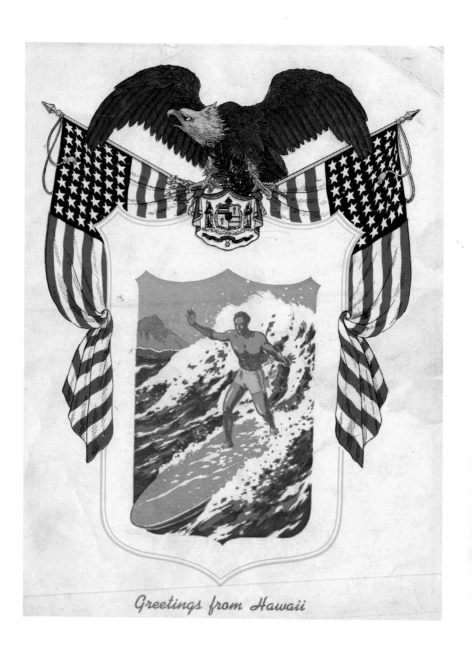

Greetings from Hawaii

Merry Christmas 1942

RECEIVING STATION
NAVY YARD
PUGET SOUND, WASHINGTON

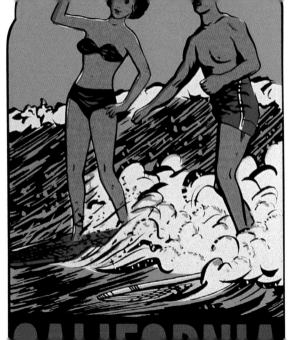

CALIFORNIA

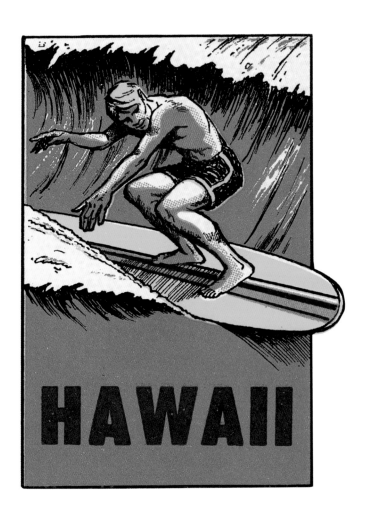

Decal, ca. 1970

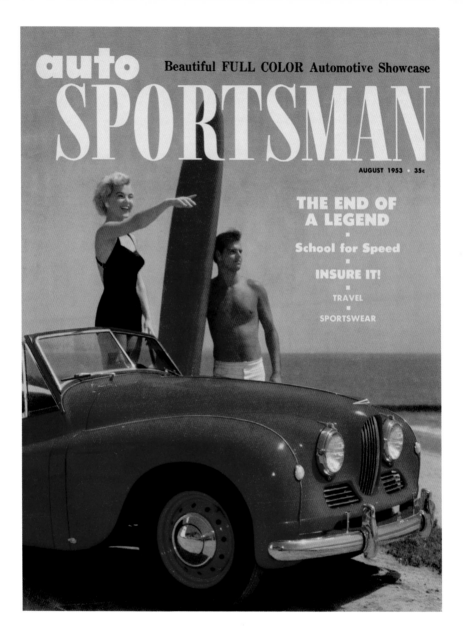

Magazine cover, 1953
▸ Menu cover, ca. 1950

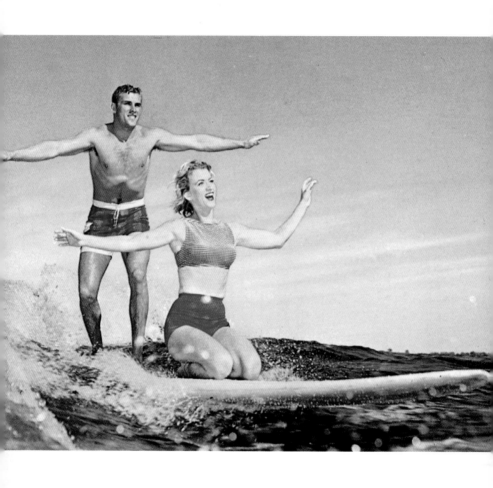

Postcard, ca. 1963
▶ Postcard, ca. 1962

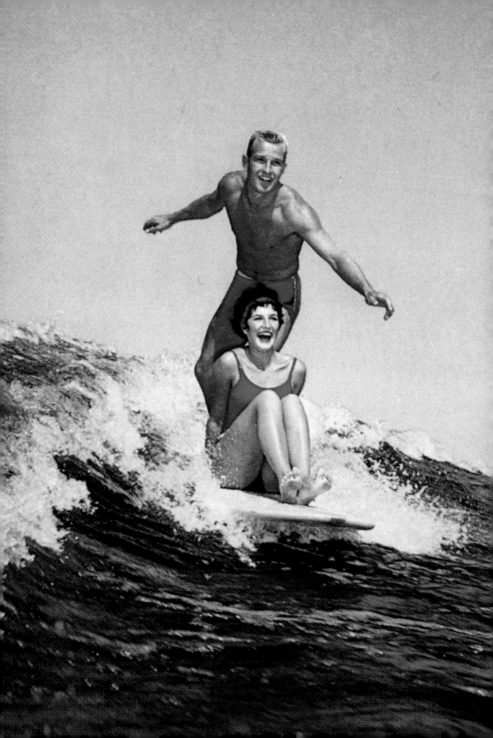

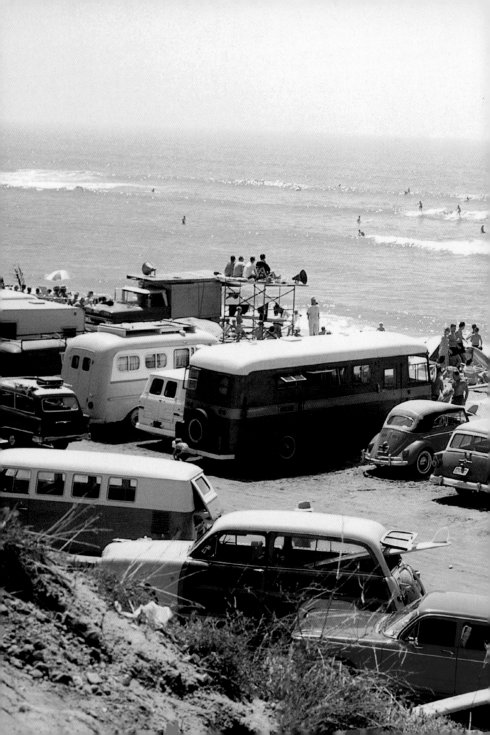

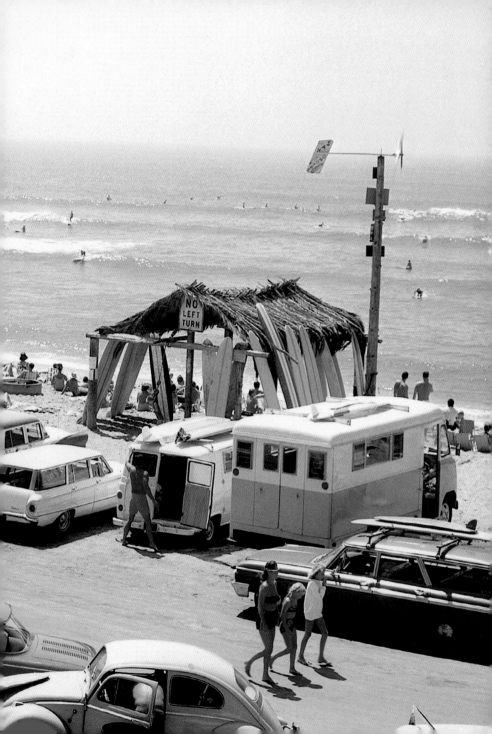

Postcard, Malibu, California, ca. 1950s
◄ San Onofre, California, photograph, LeRoy Grannis, 1963

MB

75-315 · 75¢

CUTE AND DEADLY SURF TWINS

OPERATION HANG TEN

PATRICK MORGAN

SURFSIDE
SEX--- 95c

BY GEORGE
SNYDER

SURF BUMS-
LIVING WITH
SAVAGE
PASSIONS
AND RAW
DESIRE:

Paperback book cover, 1966
◄ Paperback book cover, 1970

Paperback book cover, 1965
► Magazine cover, 1962

MAN'S

NINE LOVE TRAPS TO BE AWARE OF!

TRUE
DANGER

35¢

DEC
A

THE NUDE BIKINI DEBS
F THE DEATH-HEAD GANG
ONCE A GIRL JOINED THEM—
SHE WAS OWNED, BODY AND SOUL

RUE EXPOSE:
YMPHO WIVES!
WE RAIDED THE
ORDELLO OF BORED
VOMEN AND THEIR
ILLICIT LOVERS

ONE MAN AGAINST A JAP ARMY
SEAMAN WILBUR LONGBAUGH'S
SEVEN YEAR LOVE BATTLE

SURFER

1963

50¢

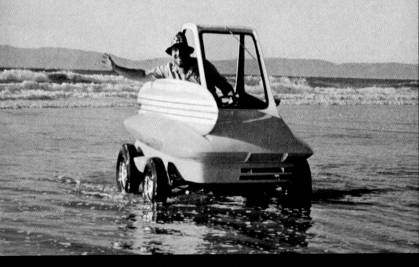

Magazine cover, 1965
◄ Cartoon booklet cover, 1963

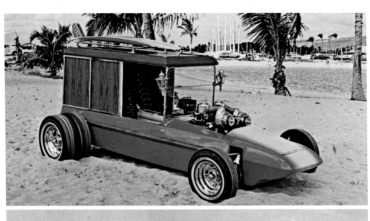

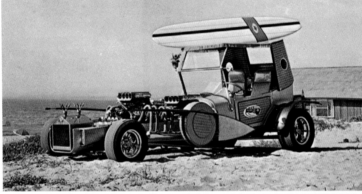

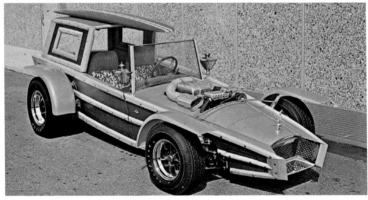

George Barris Kustom Kars, postcards, 1960s
► Magazine cover, 1963

CAR CRAFT

IND

JULY 1963 **35c** 40c IN CANADA

CAMSHAFT KITS
What, why and how of proper cam
and valve train installations

TIPS FOR TROPHIES
Ideas for winning show points

Scuderia Scale's New Dragster Bodies

TRUE
BOOK BONUS

THE HELL SURFERS

"A weirdo gang of thrill-seekers on a sin and crime rampage..." —The Recor

JULY

FOR MEN ONLY

IND ◆

40¢

From the $5.95 Shocker

"I Am A 'For Millionaires Only' Call Girl

COMMANDER
"BULLETS" HAYS

LONE WOLF ACE THE NORTH VIET CAN'T SHOOT DOWN

Yank Who Raided The Island Of "PASSION HOSTAGES"

PROFITS: $4 BILLION TAXES:

Sickening Scandal Of Our Fat, "Free Ride" Oil Companies

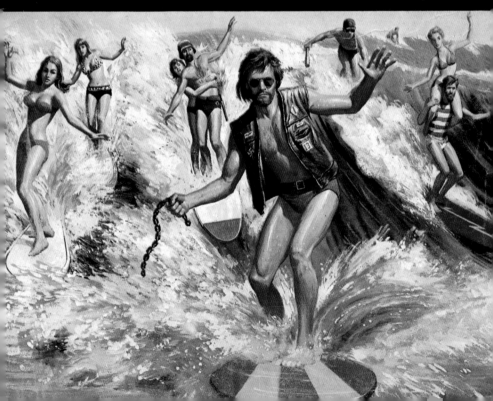

Comic book cover, 1968
◄ Magazine cover, 1969

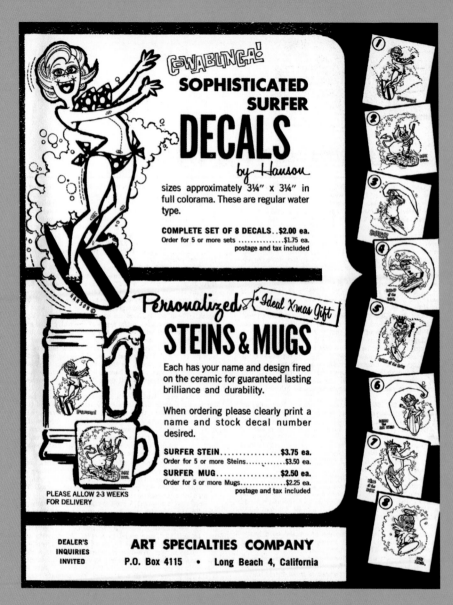

Magazine advertisement, 1962

▶ Poster, 1965

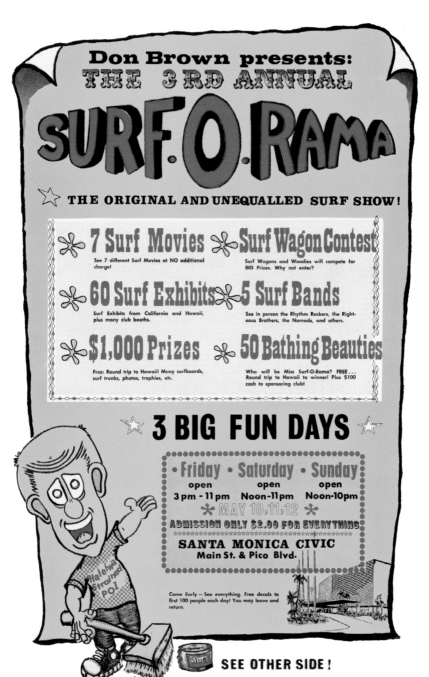

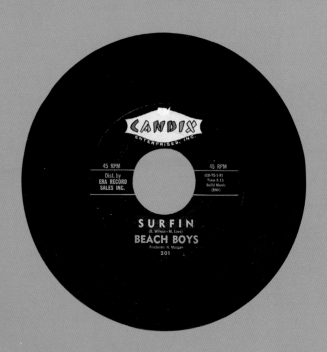

45 RPM record, 1962

Let's Go Trippin', Dick Dale and His Del-Tones, 1961

Mr. Moto, The Bel Airs, 1961

Surfin', The Beach Boys, 1961

Misirlou, Dick Dale and His Del-Tones, 1962

Surfer's Stomp, The Mar-kets, 1962

TOP TEN SURF SONGS

Wipe Out, The Surfaris, 1962

Penetration, The Pyramids, 1963

Surf City, Jan and Dean, 1963

Surfer Girl, The Beach Boys, 1963

Hawaii Five-O, The Ventures, 1969

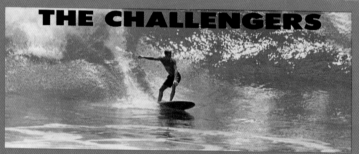

SURFBEAT

THE CHALLENGERS

BULLDOG · KAMI-KAZE · LET'S GO TRIPPIN · RAMROD · MR. MOTO
RED RIVER ROCK · MISERLOU · LATIN'IA · SURFIN' SAFARI
MOVIN' & GROOVIN' · VAMPIRE · TORQUAY—VAULT LP 100

Album cover, 1962

Album cover, 1963

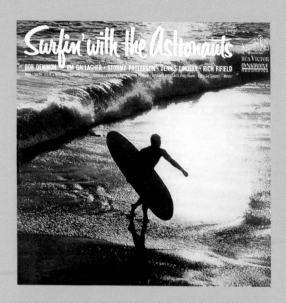

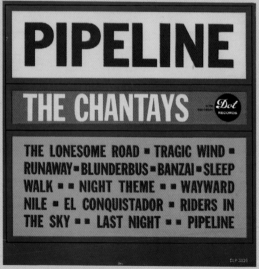

top: Album cover, 1963
bottom: Album cover, 1963
▶ Advertisement, 1963

FOR THE FINEST IN TEEN MUSIC..
DISCRIMINATING SURFERS PREFER
THE CHALLENGER'S BAND

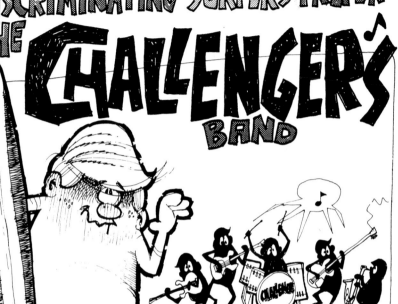

...MURPHY DOES...

INFORMATION AND
BOOKINGS:
RICHARD DELVY
1800 NORTH ARGYLE AVE
SUITE #300-A
HOLLYWOOD, CALIF. 90028
TELEPHONE (213) HO 4-5577

AND GUESS WHAT ELSE GANG..!
YOU CAN NOW SEND FOR THE
STUNNING NEW THREE COLOR
CHALLENGER'S BAND DECAL
FOR ONLY 15 CENTS PLUS SELF
ADDRESSED STAMPED
ENVELOPE.

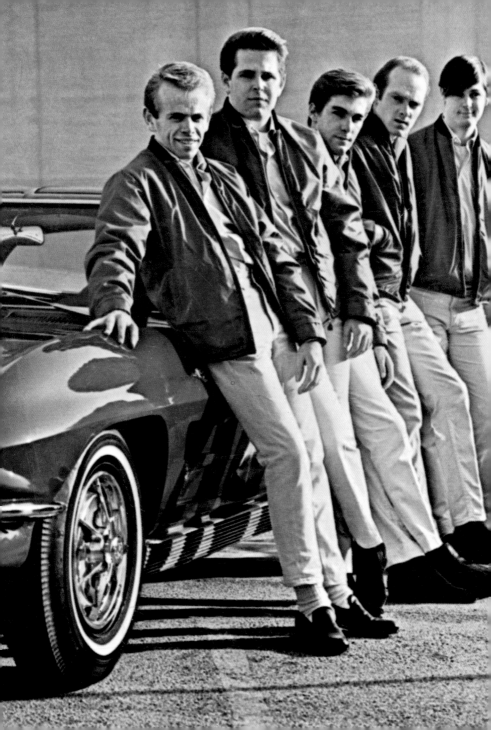

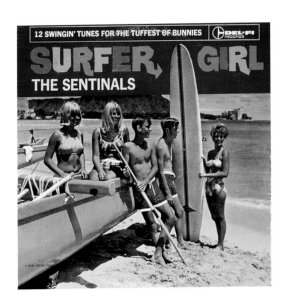

top: Album cover, 1964
bottom: 45 RPM record sleeve, 1963
◄ Song folio cover, detail, 1964

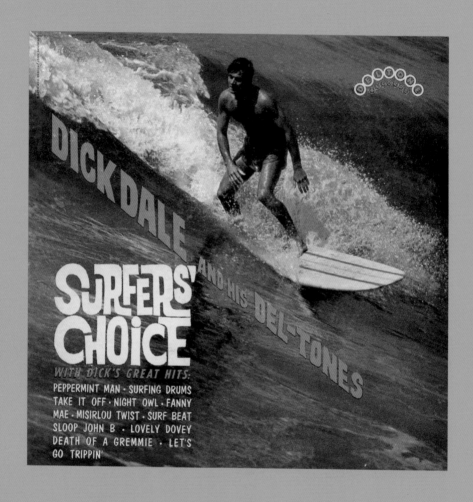

Album cover, 1962

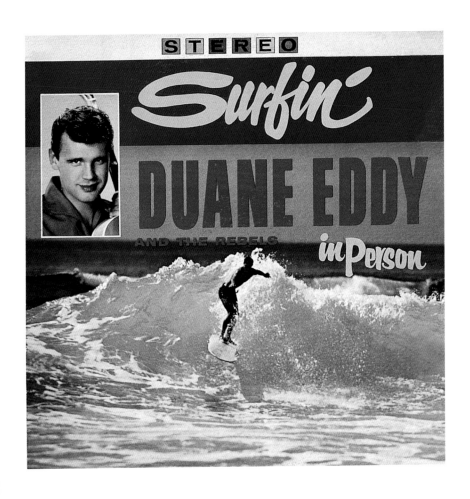

Album cover, 1963

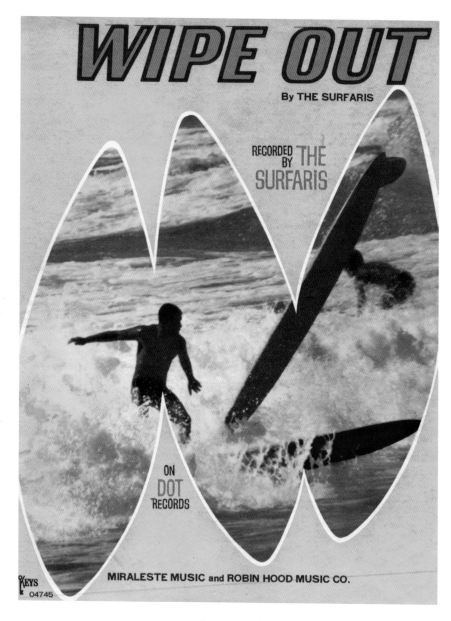

Sheet music, 1963

Advertisements, ca. 1964

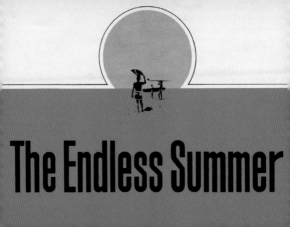

Surf, John Severson (1958)

Gidget, Paul Wendkos (1959)

Barefoot Adventure, Bruce Brown (1960)

Blue Hawaii, Norman Taurog (1961)

Surfing Hollow Days, Bruce Brown (1962)

Going My Wave, John Severson (1962)

Angry Sea, John Severson (1963)

TOP SURF MOVIES

Beach Party, William Asher (1963)

Ride the Wild Surf, Don Taylor (1964)

The Endless Summer, Bruce Brown (1966)

Pacific Vibrations, John Severson (1970)

Five Summer Stories, Greg MacGillivray and Jim Freeman (1972)

Big Wednesday, John Milius (1978)

Apocalypse Now, Francis Ford Coppola (1979)

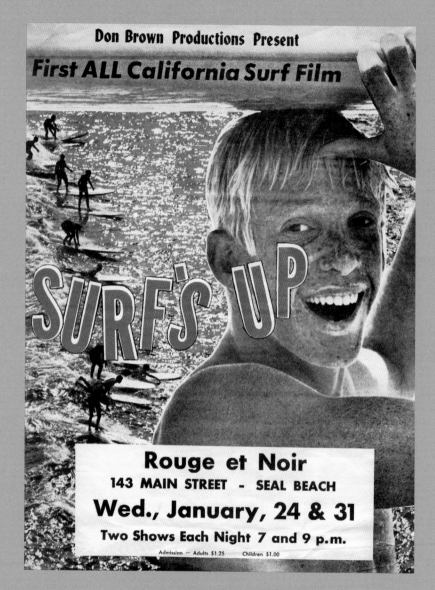

Movie handbill, 1961

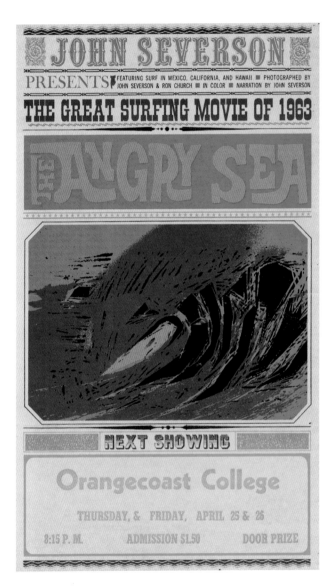

Movie poster, 1963

SURFING MOVIE

John SEVERSON PRESENTS

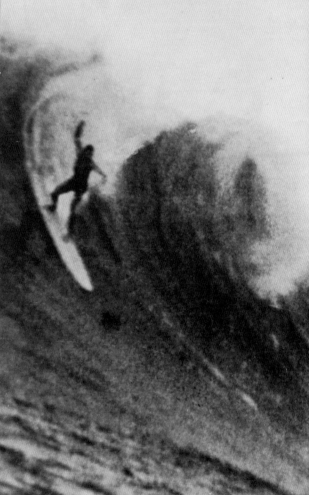

"SURF FEVER"

All New 1960 Color Surfing Adventure
filmed in HAWAII · CALIF · MEXICO and NEVADA!

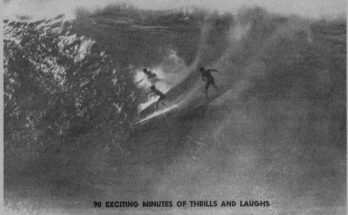

BRUCE BROWN PRESENTS

"SURF CRAZY"

Feature Length — Full Color "Spectacular"

90 EXCITING MINUTES OF THRILLS AND LAUGHS

Filmed In Old Mexico, Hawaii, & California

BYRON KOUGH

PAT CURREN PETER COLE

Largest wave to hit
Hawaii in past 5 years

Jan. 17,19(
WAIMEA BAY, HAWA

"IN PERSON" — BRUCE BROWN — WORLD ACCLAIMED LECTURER, PHOTOGRAPHER &
SURFER! ONE NIGHT ONLY!

PASADENA CITY COLLEGE — SEXSON AUD.

1570 E. COLORADO BLVD.

FRIDAY — JUNE 7 — 8:00 P.M.

ADMISSION $1.50—AT THE DOOR OR IN ADVANCE FROM ▓▓▓▓▓▓▓▓▓▓▓▓▓
FREE DOOR PRIZES! CIRCLE K CLUB
SPONSORED BY: PASADENA CITY COLLEGE ▓▓▓▓▓▓▓▓▓▓▓
CIRCLE K CLUB

Movie handbill, 1959
◄ Movie handbill, 1960
► Movie poster, 1969
►► Movie advertisement, 1978

ADMISSION $1.25
8 P. M. DOOR PRIZE!

JOHN SEVERSON PRESENTS
BIG WEDNESDAY
1961 SURF
MOVIE

FILMED IN HAWAII · CALIFORNIA and for the 1ST TIME PERU SOUTH AMERICA
· NARRATION BY JOHN SEVERSON ·

2 NIGHTS ONLY
House of Hospitality Auditorium
Balboa Park, San Diego
SUNDAY and MONDAY
MAY, 14 & 15

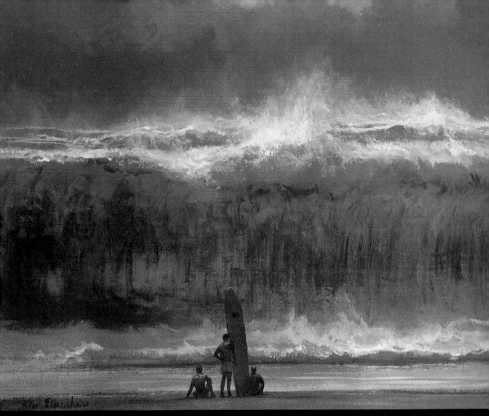

A day will come that is like no other...
and nothing that happens after will ever be the same

BIG WEDNESDAY

an A-TEAM production "BIG WEDNESDAY"

...-MICHAEL VINCENT · WILLIAM KATT · GARY BUSEY co-starring PATTI D'ARBANVILLE · LEE PURCE...

screenplay by JOHN MILIUS and DENNIS AABERG produced by BUZZ FEITSHANS directed by JOHN MILIUS

executive producers ALEX ROSE and TAMARA ASSEYEV surfing sequences produced by GREG MACGILLIVRAY

music by BASIL POLEDOURIS · PANAVISION® · METROCOLOR® □□ DOLBY® STEREO

From Warner Bros. Ⓦ A Warner Communications Com...

This Summer From Warner Bros.

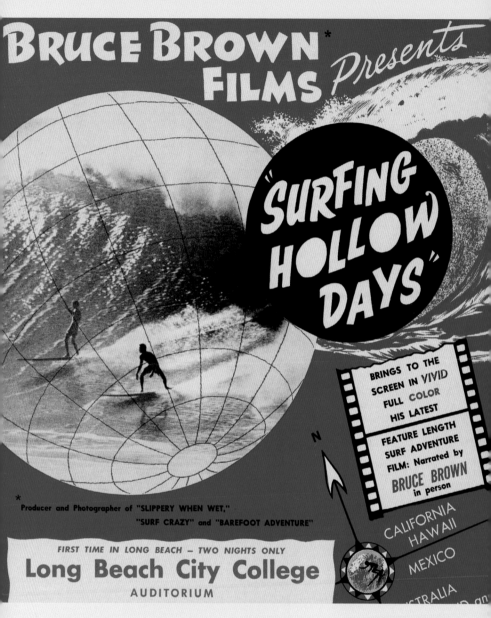

BRUCE BROWN* FILMS *Presents*

"SURFING HOLLOW DAYS"

BRINGS TO THE SCREEN IN VIVID FULL COLOR HIS LATEST

FEATURE LENGTH SURF ADVENTURE FILM: Narrated by **BRUCE BROWN** in person

* Producer and Photographer of "SLIPPERY WHEN WET," "SURF CRAZY" and "BAREFOOT ADVENTURE"

FIRST TIME IN LONG BEACH — TWO NIGHTS ONLY

Long Beach City College
AUDITORIUM

N

CALIFORNIA
HAWAII
MEXICO
STRALIA

Movie poster, 1962
▶ Movie handbill, 1972
▶▶ Movie poster, 1964
▶▶▶ Movie poster, 1964

Il vous reste encore quelque chose à voir

LE DERNIER FILM de
RODNEY SUMPTER

"OCEANS"

Le Meilleur Film de Surf
qui n'est jamais été fait

Filmé à Biarritz - Hawaï
Australie - Sud - Afrique

au PAX-CINÉMA

LA NEGRESSE - **BIARRITZ**

Tous les VENDREDI, SAMEDI et DIMANCHE
du Mois d'Août et Septembre 1972
—— à **21** heures **15** ——

Prix d'Entrée : **8 francs**

Imp. Mendiboure

141

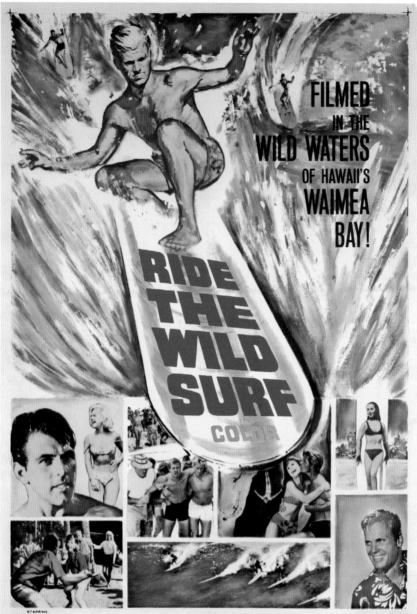

FILMED IN THE WILD WATERS OF HAWAII'S WAIMEA BAY!

RIDE THE WILD SURF
IN COLOR

STARRING
FABIAN · SHELLEY FABARES · TAB HUNTER · BARBARA EDEN · PETER BROWN · ANTHONY HAYES · SUSAN HART
and JAMES MITCHUM as Eskimo · Written & Produced by JO and ART NAPOLEON · Directed by DON TAYLOR · A Jana Film Enterprises Picture
A COLUMBIA PICTURES Release

142

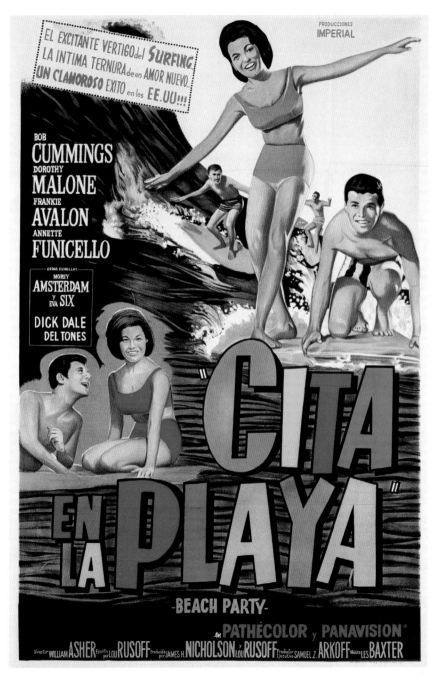

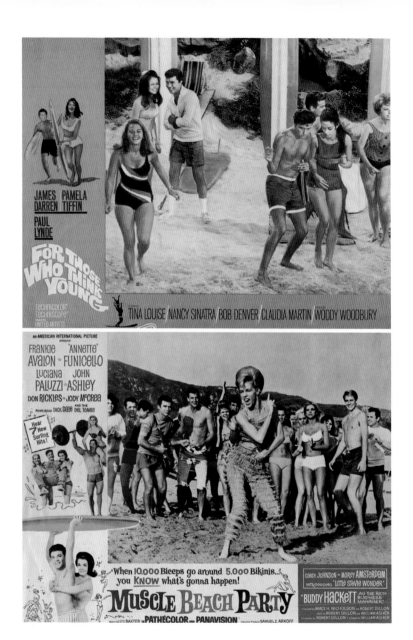

top: Lobby card, 1965
bottom: Lobby card, 1964
▶ Movie poster, 1964

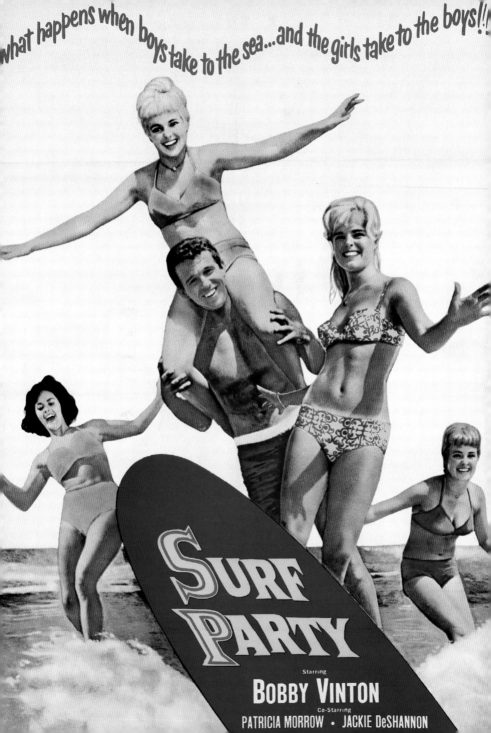

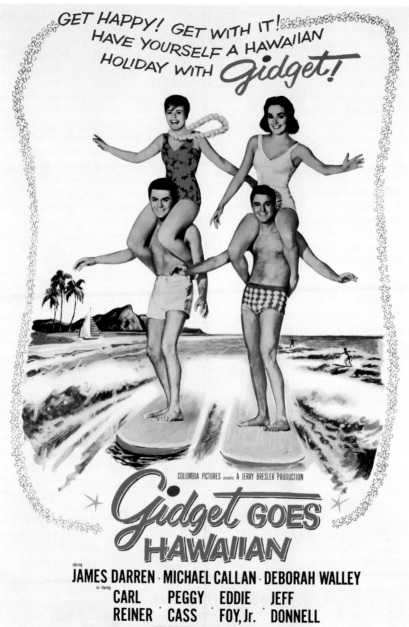

GET HAPPY! GET WITH IT! HAVE YOURSELF A HAWAIIAN HOLIDAY WITH *Gidget!*

COLUMBIA PICTURES presents A JERRY BRESLER PRODUCTION

Gidget GOES HAWAIIAN

starring

JAMES DARREN · MICHAEL CALLAN · DEBORAH WALLEY

co-starring

CARL REINER · PEGGY CASS · EDDIE FOY, Jr. · JEFF DONNELL

with VICKI TRICKETT · JOBY BAKER · Screenplay by RUTH BROOKS FLIPPEN

Based on characters created by FREDERICK KOHNER · Produced by JERRY BRESLER · Directed by PAUL WENDKOS

EASTMAN **COLOR**

146

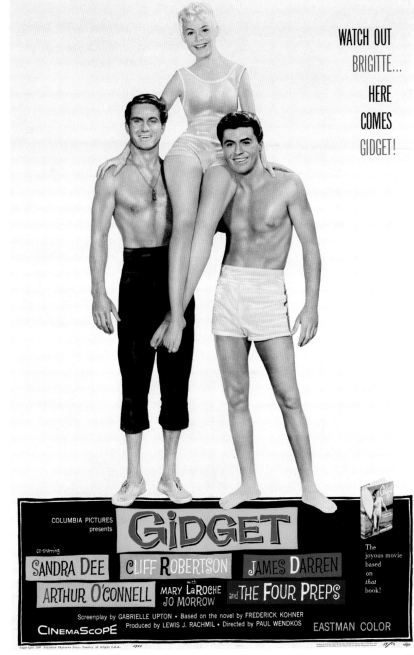

WATCH OUT
BRIGITTE...
HERE
COMES
GIDGET!

COLUMBIA PICTURES
presents

GiDGET

co-starring
SANDRA DEE · CLiFF RoBeRTSoN · JAMES DARREN
with
ARTHUR O'CONNELL · MARY LaRoCHE · and THE FOUR PREPS
JO MORROW

Screenplay by GABRIELLE UPTON · Based on the novel by FREDERICK KOHNER
CINEMASCOPE Produced by LEWIS J. RACHMIL · Directed by PAUL WENDKOS EASTMAN COLOR

The
joyous movie
based
on
that
book!

147

A Film by Greg Macgillivray and Jim Freeman

Five Summer Stories

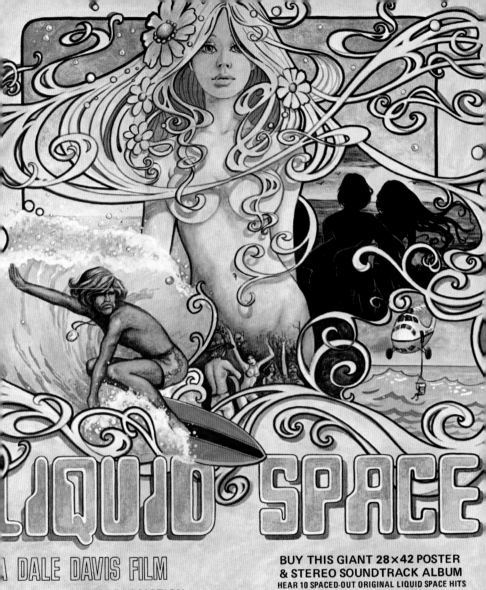

LIQUID SPACE

A DALE DAVIS FILM

VATCH FOR THIS GREAT MOTION
ICTURE – PLAYING NEARBY SOON!

BUY THIS GIANT 28×42 POSTER
& STEREO SOUNDTRACK ALBUM
HEAR 10 SPACED-OUT ORIGINAL LIQUID SPACE HITS
PERFORMED BY "TRUCKIN'" MUSICAL SUPERVISION
BY DENNY DIANTE
THIS FANTASTIC 13-ARTIST GROUP WAILES ON "LIQUID SPACE," "TREES," "RIDIN' ON
A RAINBOW," "HYMN ONE," "MY TURN'S COMIN' ROUND," "STAND UP & GET DOWN,"
"WHISPERS," "CRIMSON EYES," "BRING IT 'ROUND" & "OUT IN THE COUNTRY."

Advertisement, 1974
◄ Movie poster, 1972
◄◄ Movie poster, 1959
◄◄◄ Movie poster, 1961

Sign, ca. 1990
◄ Advertisement, detail, 1982
◄◄ Advertisement, 1975

Malibu, California, USA

Maverick's, Central California, USA

San Onofre, California, USA

Steamer Lane, Santa Cruz, California, USA

TOP SURF SPOTS

Waimea Bay, North Shore, Hawai'i, USA

Pipeline, North Shore, Hawai'i, USA

Makaha, North Shore, Hawai'i, USA

The Wedge, Newport Beach, California, USA

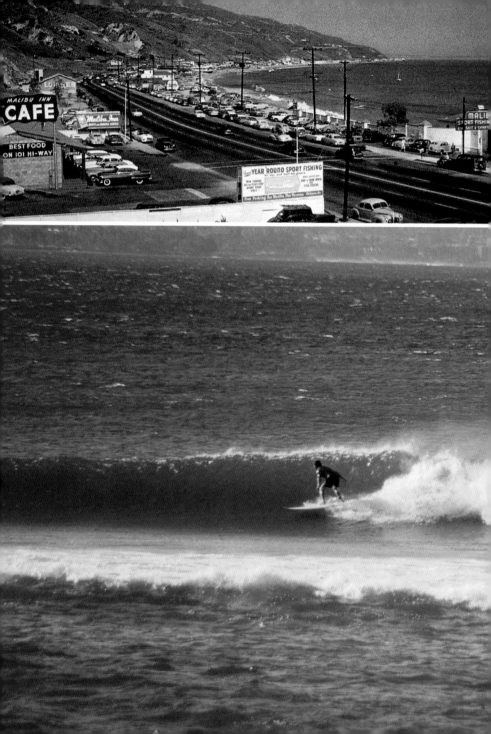

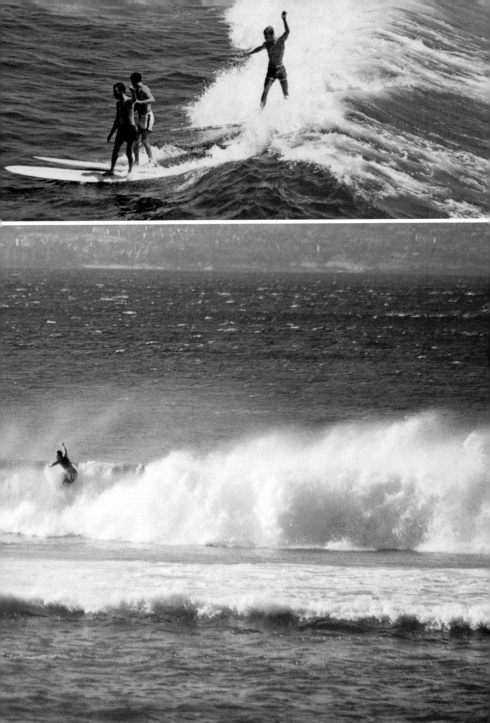

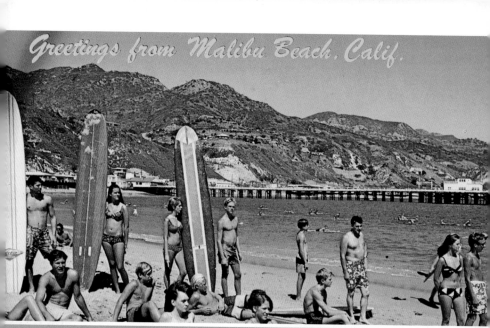

Greetings from Malibu Beach, Calif.

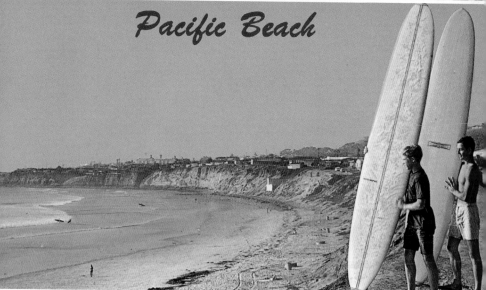

Pacific Beach

top: Postcard, ca. 1968
bottom: Postcard, 1968
◄ top: Postcard, ca. 1967
◄ Photograph, Maalea Bay, 1990s
◄◄ top: Postcard, ca. 1953

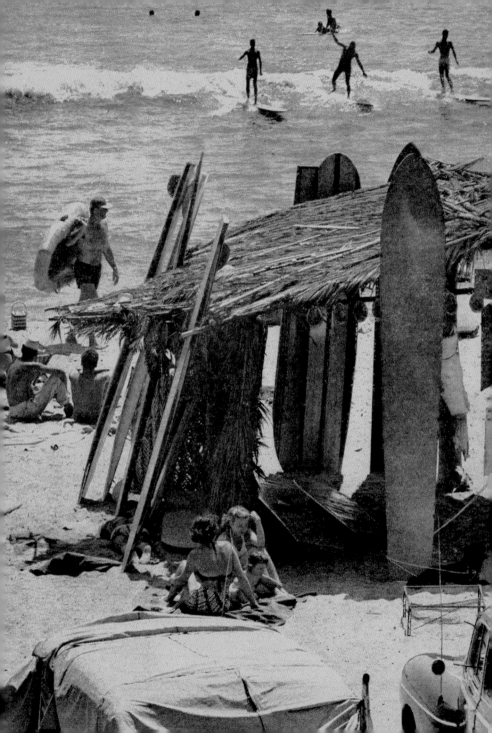

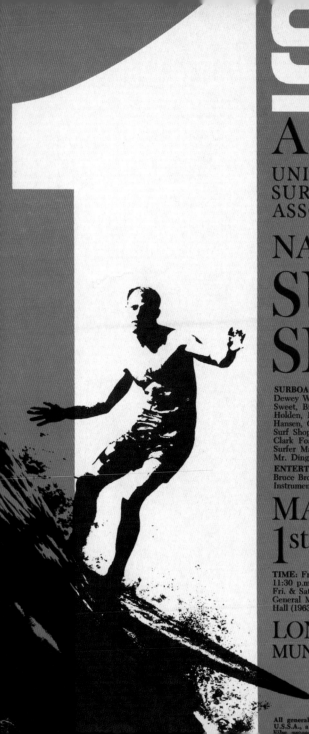

1ST

ANNUAL

UNITED STATES SURFING ASSOCIATION

NATIONAL SURF SHOW

SURBOARDS BY:
Dewey Weber, Hap Jacobs, Greg Noll, Con Colburn, Da
Sweet, Bing Copeland, Allen Fass, Richard Harbour, I
Holden, Dale Velzy, Gordon & Smith, Hobie Alter, D
Hansen, Gordie Duane AND Surfco Mfg. Co., Santa C
Surf Shop, Seal Beach Surf Shop, Jacks Surf Shop AL
Clark Foam Products, Harold Walker Co., Jantzen, In
Surfer Magazine, Doris Moore Originals, Take of Haw
Mr. Ding, Surfing Illustrated PLUS

ENTERTAINMENT FEATURING:
Bruce Brown Films, John Severson Films WITH Vocal a
Instrumental Groups Highlighting the Show.

MARCH
1st 2nd 3rd

TIME: Friday — 12 noon-11:30 p.m. / Saturday — 10 a.m
11:30 p.m. / Sunday — 10 a.m.-6 p.m.; **SURFING FILM**
Fri. & Sat. 1:30 p.m. and 8 p.m. / Sun. — 1:30 p.m.; US
General Meeting — Sat., March 2 — 11:00 a.m. in Conce
Hall (1963 members only).

LONG BEACH
MUNICIPAL AUDITORIU

$1.75
1963
USSA members
75c
SURFING FILM

All general admission proceeds will go to the general fund of
U.S.S.A., a non-profit organization, for utilization in its annual we

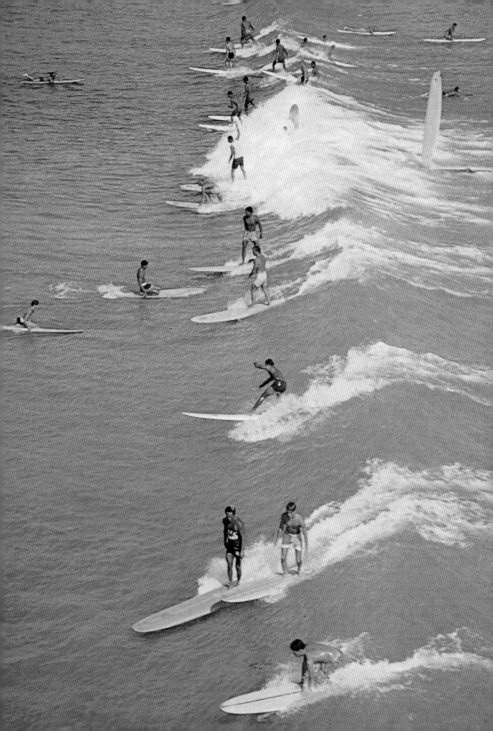

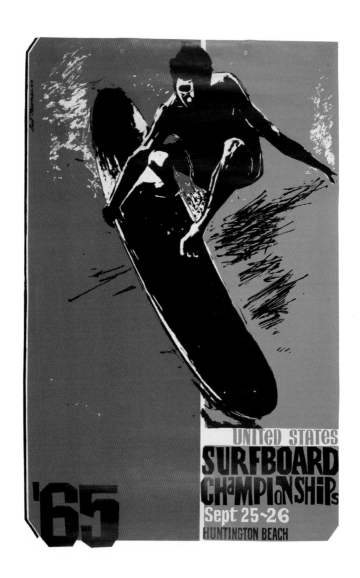

Poster, 1965
◄ Postcard, ca. 1962
◄◄ Poster, 1963
◄◄◄ Photograph, 1950

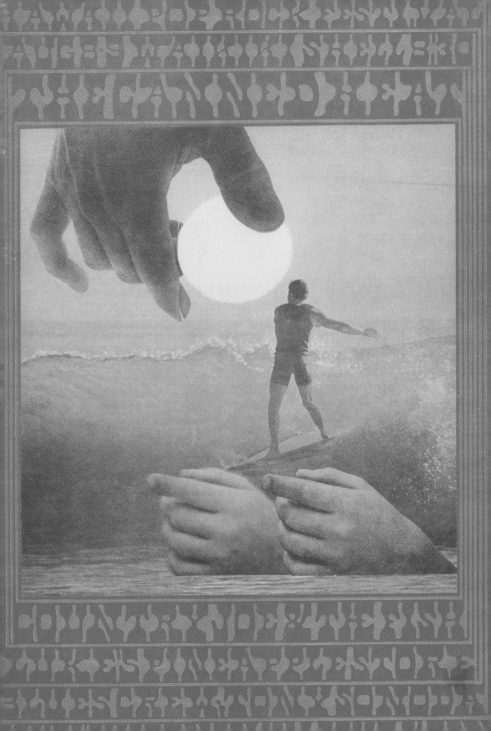

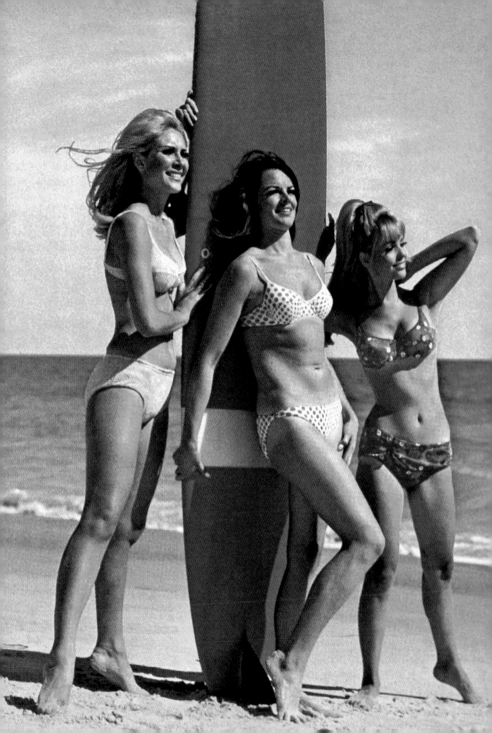

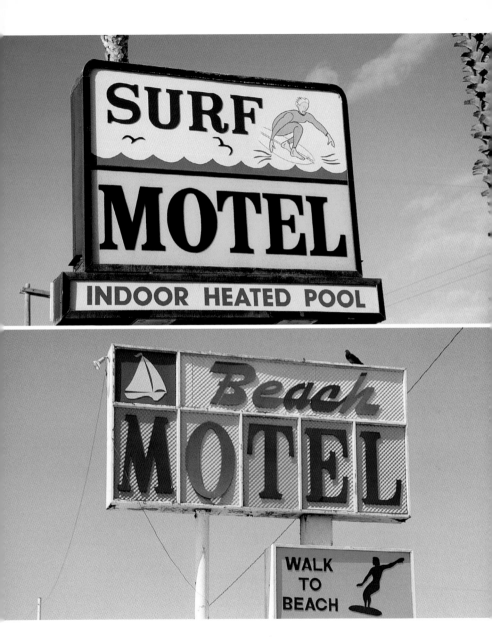

top: Sign, ca. 1969
bottom: Sign, ca. 1957
◄ Postcard, ca. 1968
◄◄ Poster, 1967

163

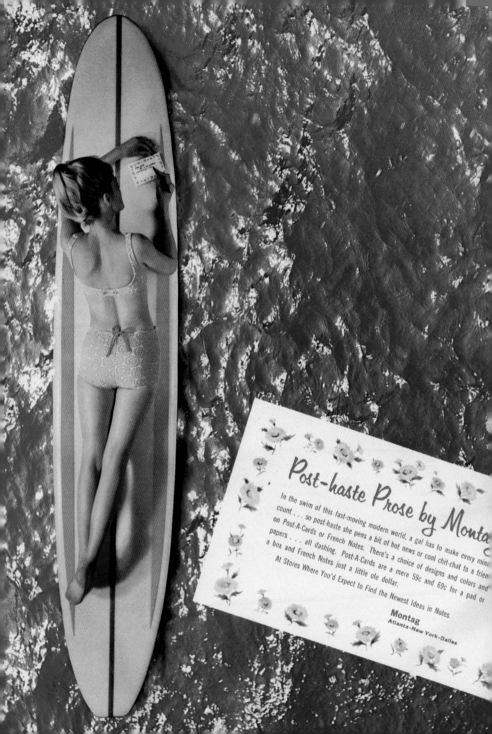

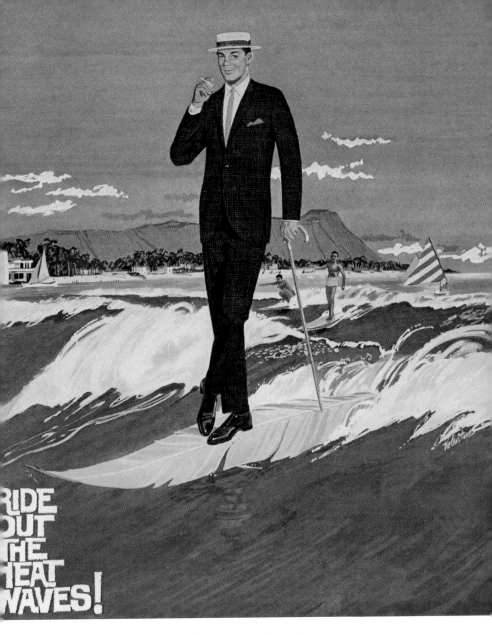

RIDE
OUT
THE
HEAT
WAVES!

Advertisement, detail, ca. 1958
◄ Advertisement, 1966
► Advertisement, ca. 1965
►► Magazine cover, 1962

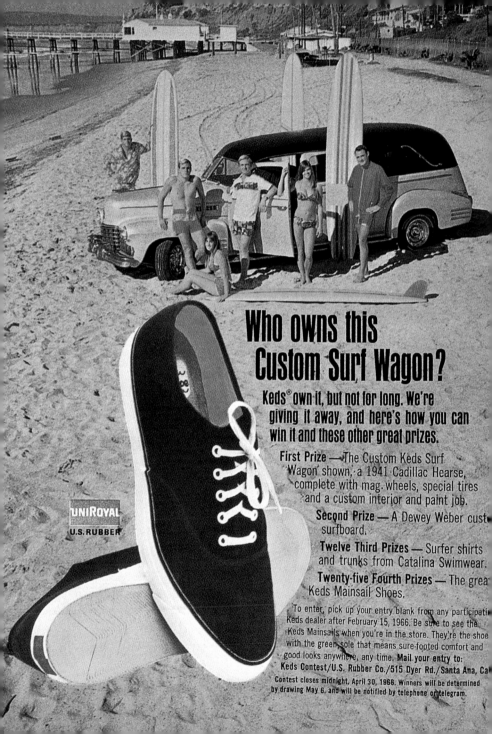

HE **SURFER** BI-MONTHLY

RM aff

A John Severson Production

75¢

VOL. 3 NO. 4 OCT.-NOV.

E INTERNATIONAL SURFING MAGAZINE

IN THIS ISSUE
♦
HUNTINGTON BEACH
♦
MURPHY
♦
SAN MIGUEL
♦
SURFER TIPS
♦
BIG CONTEST SECTION

"LITTLE JOHN" RICHARDS · OCEANSIDE, CALIFORNIA

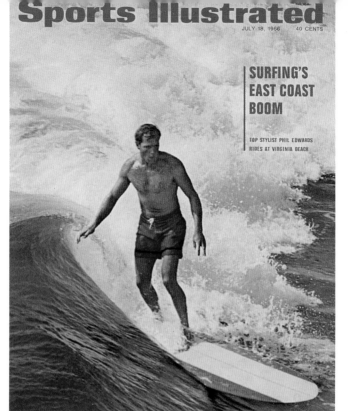

Sports Illustrated

JULY 18, 1966 40 CENTS

SURFING'S EAST COAST BOOM

TOP STYLIST PHIL EDWARDS
RIDES AT VIRGINIA BEACH

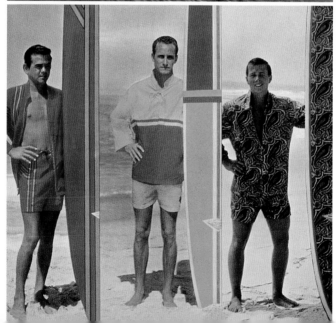

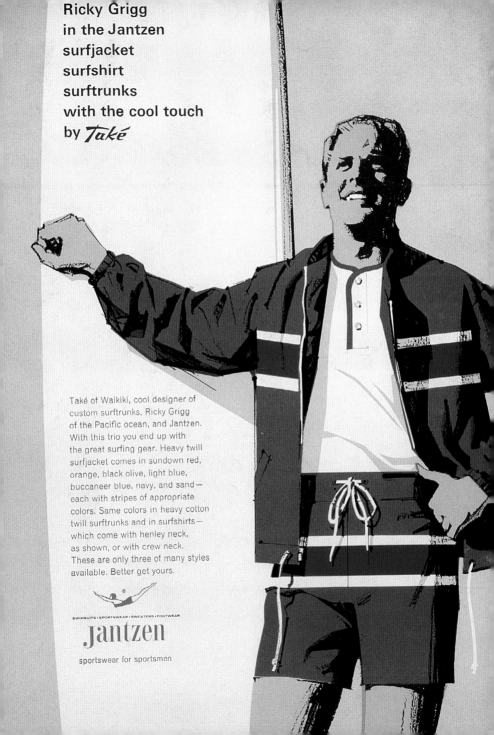

**Ricky Grigg
in the Jantzen
surfjacket
surfshirt
surftrunks
with the cool touch
by** *Také*

Také of Waikiki, cool designer of
custom surftrunks, Ricky Grigg
of the Pacific ocean, and Jantzen.
With this trio you end up with
the great surfing gear. Heavy twill
surfjacket comes in sundown red,
orange, black olive, light blue,
buccaneer blue, navy, and sand—
each with stripes of appropriate
colors. Same colors in heavy cotton
twill surftrunks and in surfshirts—
which come with henley neck,
as shown, or with crew neck.
These are only three of many styles
available. Better get yours.

SWIMSUITS · SPORTSWEAR · SWEATERS · FOOTWEAR

Jantzen

sportswear for sportsmen

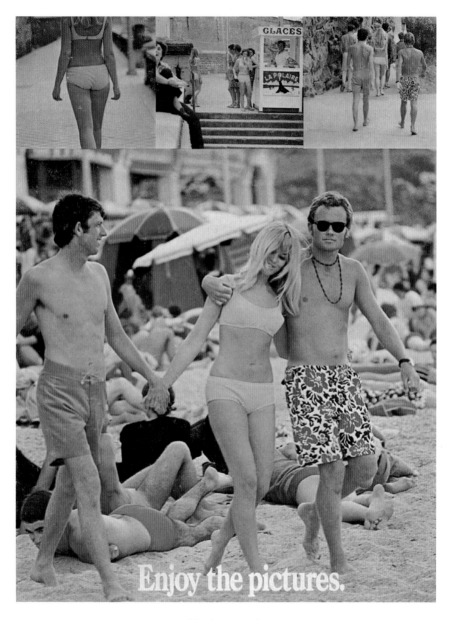

Enjoy the pictures.

Advertisement, 1969

◄ Advertisement, 1964

◄◄ top: Magazine cover, 1966

◄◄ bottom: Advertisement, detail, 1964

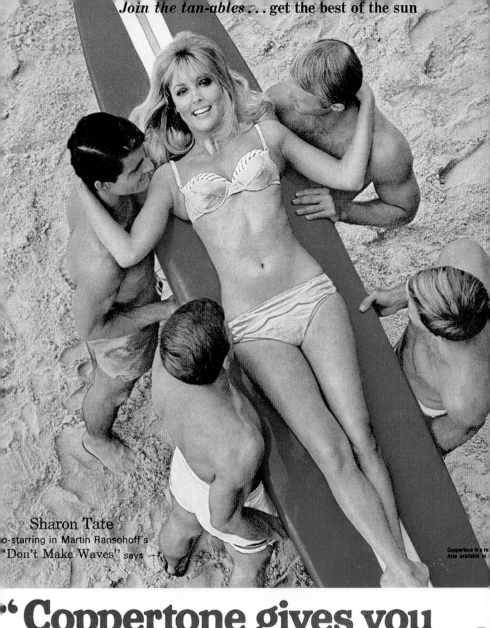

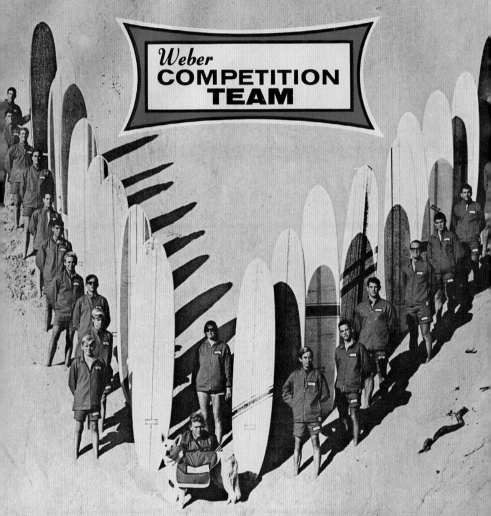

Weber COMPETITION TEAM

BUILT *for* PROS

Miscellaneous decals, 1960s

◄ Advertisement, ca. 1964

◄◄ Advertisement, 1967

173

WHAT A LAY-OUT ✳

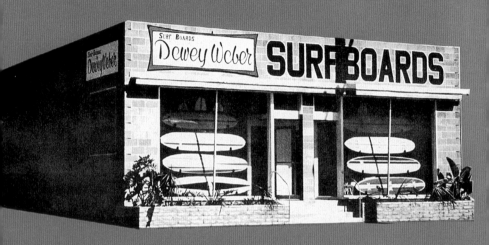

✳ FOR BUILDING CUSTOM SURFBOARDS ✳

✳ The **new Dewey Weber Surfboard Shop** was designed and built with one thing in mind. To keep all phases of construction and sales under one roof. With the completion of our new building, we have become the **largest surfboard company** with all phases of production (shaping, fiberglassing, and selling) **in one building.** This protects the customer against damages to the product that are common when the surfboard has to be transported, by motor vehicle, to various shops to complete different phases of construction. We are able to insure the customer a high-quality surfboard constructed with the help of only a handful of **expertly** skilled craftsmen who work within the confines of the same building that houses our sales room. We kept the customer in mind when we designed and built our new shop—keep us in mind when looking for a **quality surfboard.**

✳ Remember, **Dewey** is in the sales room to lend personal assistance to each customer.

4144 Lincoln Boulevard • Venice, California • Exmont 1-3444

After thoroughly testing all available materials for surfboards, we have put together a virtually new *Bing Surfboard* and we are proud to say that we believe this is the best-riding and most durable surfboard ever built. The materials we have chosen include Clark's new isophthalic polyester foam and two layers of ten-ounce, volan-finished, flatweave glass cloth, impregnated with light-stabilized isophthalic resin.

Due to the cost of our new materials and the fact that we are limiting our production so that our quality will not vary during the summer season, we have found it impossible to wholesale our boards through other outlets. Therefore, we have introduced free packing and shipping anywhere in California and a ten dollar fee to any other state in the United States.

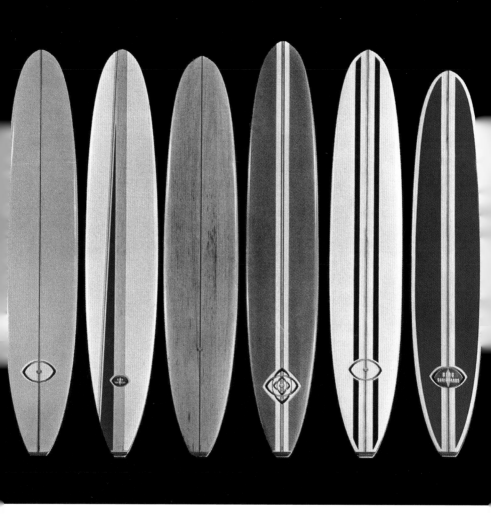

Advertisement, 1963
◄ Advertisement, 1963

By **HANSEN** **Cardiff**

CUSTOM SURFBOARDS

SURF BOARDS

CLARK

BING

BING SURFBOARDS

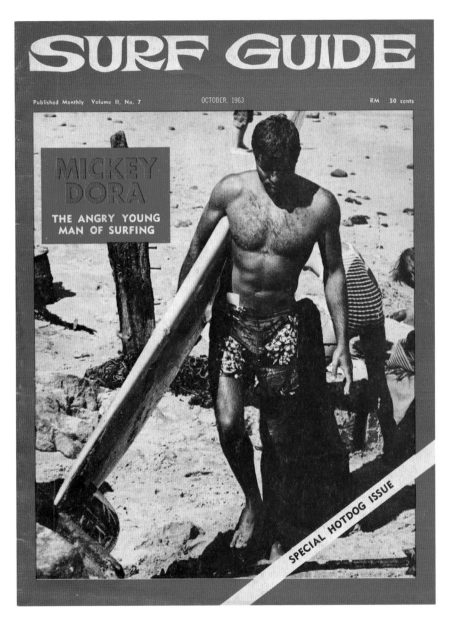

SURF GUIDE

Published Monthly Volume II, No. 7 OCTOBER, 1963 RM 50 cents

MICKEY DORA

THE ANGRY YOUNG MAN OF SURFING

SPECIAL HOTDOG ISSUE

Magazine cover, 1963
◄ Advertisement, detail, 1963

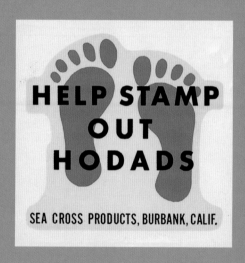

Betty: Cool female/chick (as in *The Flintstones'* Betty Rubble)/Coole Braut/Frau (nach Betty Rubble aus *Familie Feuerstein*)/fille agréable et séduisante (comme Betty dans les *Pierrafeu*)

Cowabunga: Exultant surfer's yell/Begeisterungsschrei der Surfer/Cri de joie des surfeurs

Dropping in: Stealing another person's wave/Einem anderen Surfer die Vorfahrt auf der Welle nehmen/« Voler » la vague d'un autre

Gnarly: Intimidating and dangerous, usually describing waves/Furcht einflößend und gefährlich, meist auf Wellen bezogen/Intimidant et dangereux (s'applique généralement à une vague)

Gremmie: Adolescent posing as a surfer/Pubertierender Möchtegernsurfer/Adolescent qui se prend pour un vrai surfeur

SURF LINGO

Hodad: Anti-surfer (usually, a greaser or hot-rodder)/Anti-Surfer (meist ein Rockabilly oder Hot-Rod-Fahrer)/Anti-surfeur

Kook: Lame/pseudo surfer/Lahmer Pseudosurfer/Mauvais surfeur

Log: Extremely heavy surfboard/Besonders schweres Surfbrett/Planche de surf extrêmement lourde

Peter heater: Urinating in a wetsuit/In den Wetsuit pinkeln/Uriner dans sa combinaison

Quasimodo: A hunched position on a surfboard (after the *Hunchback of Notre Dame*)/Geduckte, vorgebeugte Haltung auf dem Surfbrett (nach dem *Glöckner von Notre Dame*)/Position voûtée, faisant penser au Quasimodo de *Notre-Dame de Paris*

Stoked: Excited, thrilled, jazzed/Begeistert, aufgeregt, aufgedreht/Excité, enthousiasmé, ravi

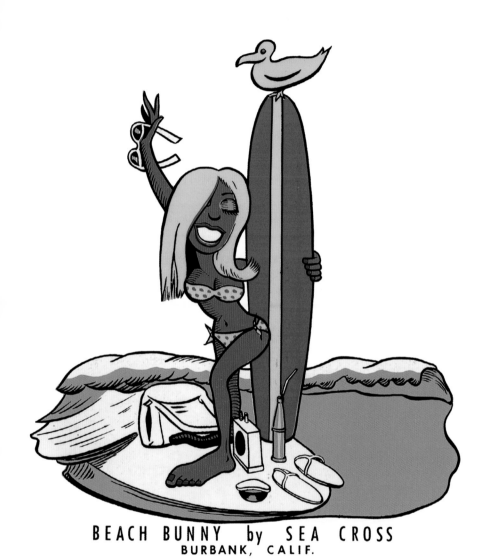

BEACH BUNNY by SEA CROSS
BURBANK, CALIF.

Decal, ca. 1963
► Decal, 1963

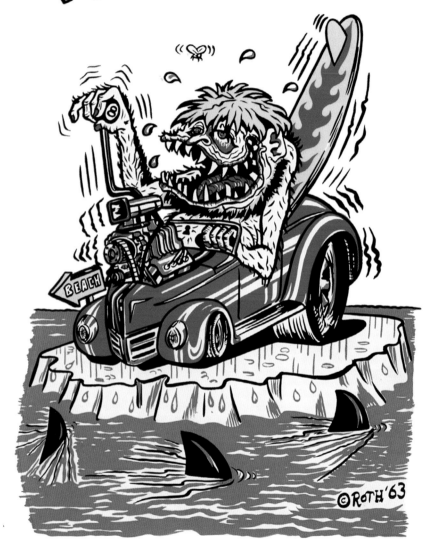

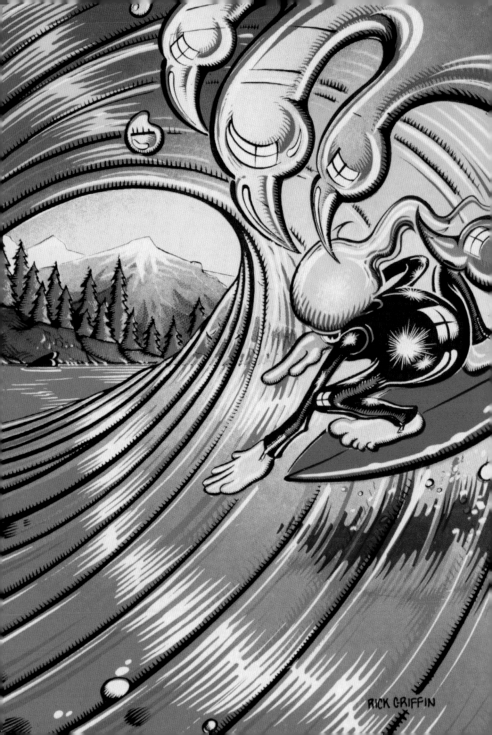

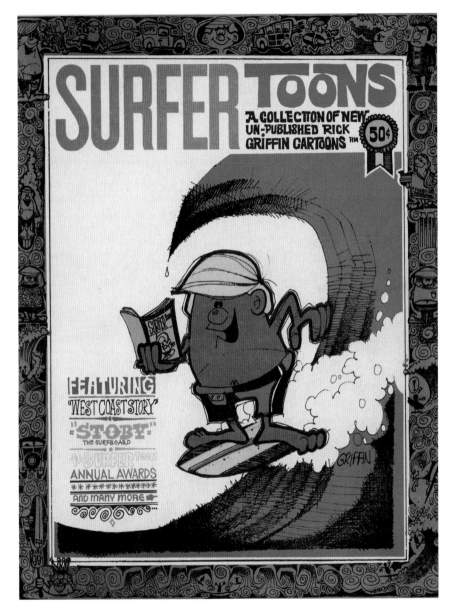

Comic book cover, 1964
◄ Comic book cover, detail, 1973
► Comic book cover, 1994

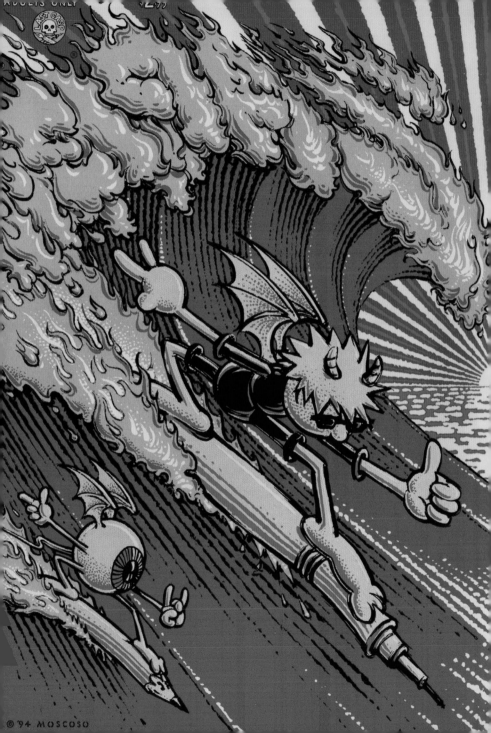

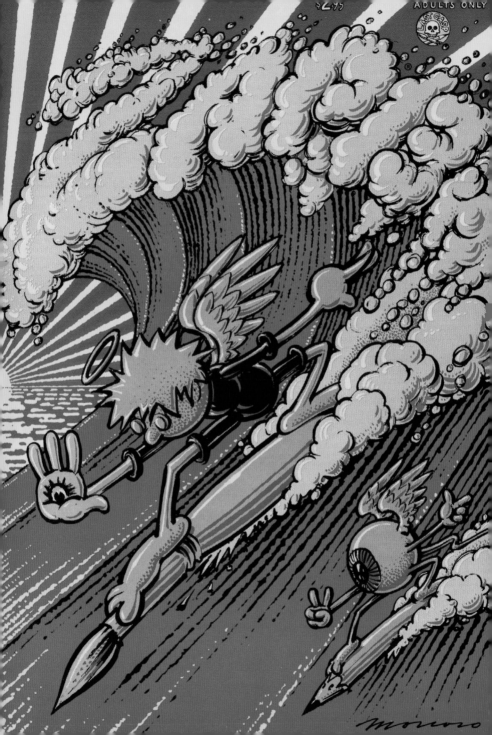

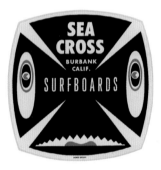

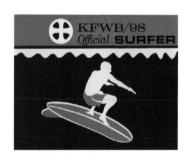

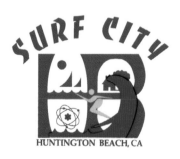

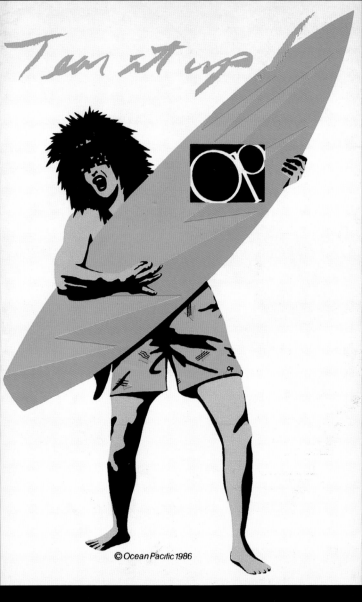

© Ocean Pacific 1986

Decal, 1986
◄ Miscellaneous decals, 1960s–70s

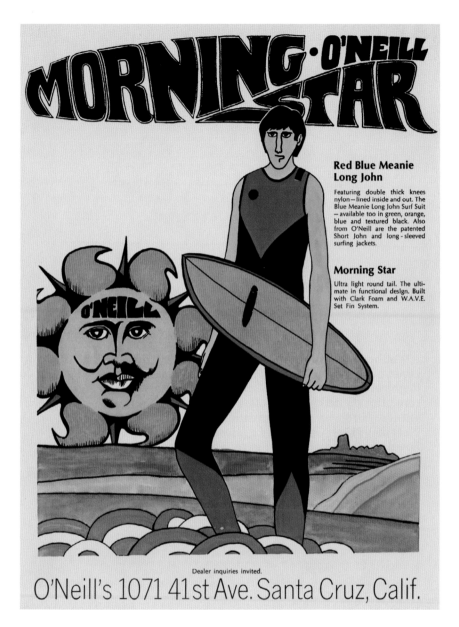

Advertisement, 1969

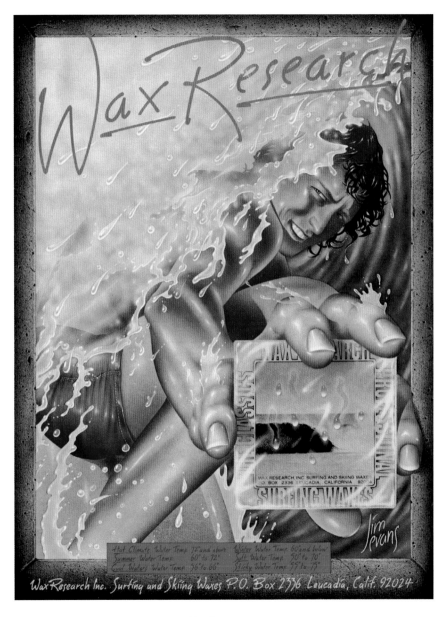

Advertisement, 1977

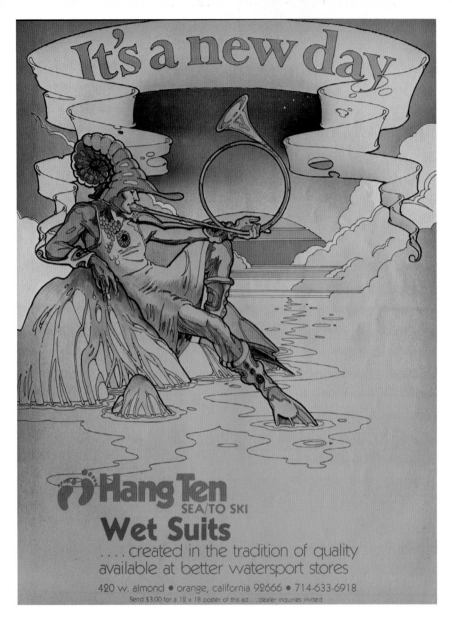

Advertisement, 1976
► Advertisement, 1977

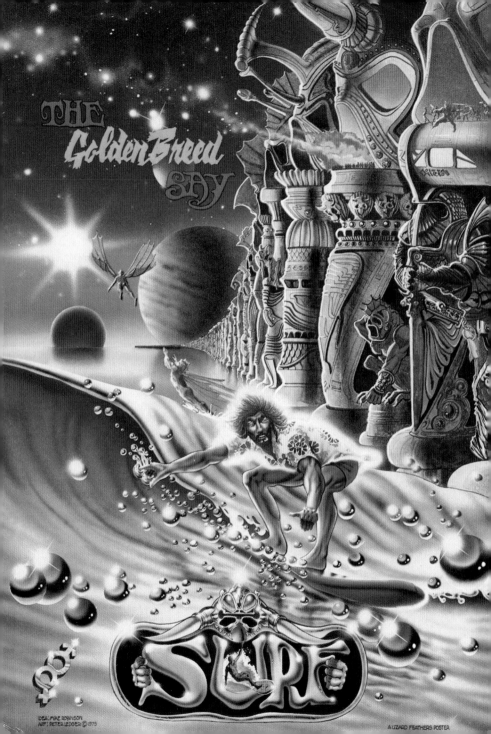

THE
Golden Breed
SAY

SURF

IDEA: MIKE ROBINSON
ART: PETER LEDGER © 1975

A LIZARD FEATHERS POSTER

All-American Ads of the 40s
W.R. Wilkerson III, Ed. Jim
Heimann / Flexi-cover, 768 pp. /
€ 29.99 / $ 39.99 / £ 19.99 /
¥ 5.900

All-American Ads of the 50s
Ed. Jim Heimann / Flexi-cover,
928 pp. / € 29.99 / $ 39.99 /
£ 19.99 / ¥ 5.900

All-American Ads of the 60s
Steven Heller, Ed. Jim Heimann /
Flexi-cover, 960 pp. / € 29.99 /
$ 39.99 / £ 19.99 / ¥ 5.900

"The ads do more than advertise products – they provide a record of American everyday life of a bygone era in a way that nothing else can." —*Associated Press*, USA

" Buy them all and add some pleasure to your life."

African Style
Ed. Angelika Taschen

Alchemy & Mysticism
Alexander Roob

All-American Ads 40ˢ
Ed. Jim Heimann

All-American Ads 50ˢ
Ed. Jim Heimann

All-American Ads 60ˢ
Ed. Jim Heimann

Angels
Gilles Néret

Architecture Now!
Ed. Philip Jodidio

Art Now
Eds. Burkhard Riemschneider,
Uta Grosenick

Atget's Paris
Ed. Hans Christian Adam

Berlin Style
Ed. Angelika Taschen

Chairs
Charlotte & Peter Fiell

Christmas
Steven Heller

Design of the 20ᵗʰ Century
Charlotte & Peter Fiell

Design for the 21ˢᵗ Century
Charlotte & Peter Fiell

Devils
Gilles Néret

Digital Beauties
Ed. Julius Wiedemann

Robert Doisneau
Ed. Jean-Claude Gautrand

East German Design
Ralf Ulrich / Photos: Ernst
Hedler

Egypt Style
Ed. Angelika Taschen

M.C. Escher

Fashion
Ed. The Kyoto Costume
Institute

HR Giger
HR Giger

Grand Tour
Harry Seidler,
Ed. Peter Gössel

Graphic Design
Ed. Charlotte & Peter Fiell

Greece Style
Ed. Angelika Taschen

Halloween Graphics
Steven Heller

Havana Style
Ed. Angelika Taschen

Homo Art
Gilles Néret

Hot Rods
Ed. Coco Shinomiya

Hula
Ed. Jim Heimann

Indian Style
Ed. Angelika Taschen

India Bazaar
Samantha Harrison,
Bari Kumar

Industrial Design
Charlotte & Peter Fiell

Japanese Beauties
Ed. Alex Gross

Krazy Kids' Food
Eds. Steve Roden,
Dan Goodsell

Las Vegas
Ed. Jim Heimann

London Style
Ed. Angelika Taschen

Mexicana
Ed. Jim Heimann

Mexico Style
Ed. Angelika Taschen

Morocco Style
Ed. Angelika Taschen

**Extra/Ordinary Objects,
Vol. I**
Ed. Colors Magazine

**Extra/Ordinary Objects,
Vol. II**
Ed. Colors Magazine

Paris Style
Ed. Angelika Taschen

Penguin
Frans Lanting

20ᵗʰ Century Photography
Museum Ludwig Cologne

Pin-Ups
Ed. Burkhard Riemschneider

Photo Icons I
Hans-Michael Koetzle

Photo Icons II
Hans-Michael Koetzle

Pierre et Gilles
Eric Troncy

Provence Style
Ed. Angelika Taschen

Pussycats
Gilles Néret

Safari Style
Ed. Angelika Taschen

Seaside Style
Ed. Angelika Taschen

Albertus Seba. Butterflies
Irmgard Müsch

**Albertus Seba. Shells &
Corals**
Irmgard Müsch

South African Style
Ed. Angelika Taschen

Starck
Ed Mae Cooper, Pierre Doze,
Elisabeth Laville

Surfing
Ed. Jim Heimann

Sweden Style
Ed. Angelika Taschen

Sydney Style
Ed. Angelika Taschen

Tattoos
Ed. Henk Schiffmacher

Tiffany
Jacob Baal-Teshuva

Tiki Style
Sven Kirsten

Tuscany Style
Ed. Angelika Taschen

Web Design: Best Studios
Ed. Julius Wiedemann

Women Artists
in the 20ᵗʰ and 21ˢᵗ Century
Ed. Uta Grosenick

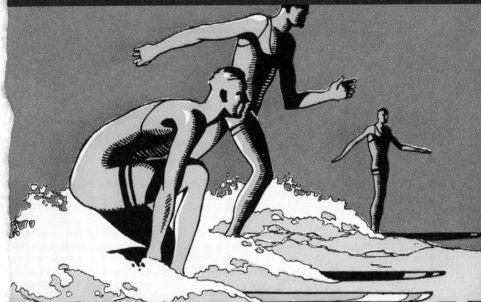